THE
MINDFUL
MAGIC
OF
FLOWER
DRAWING

For Casper and Fleur

THE MINDFUL MAGIC OF FLOWER DRAWING

A STEP-BY-STEP GUIDE TO DRAWING & DOODLING FLOWERS

Chloe Wilson

ilex

An Hachette UK Company
www.hachette.co.uk

First published in the UK in 2024 by ILEX,
an imprint of Octopus Publishing Group Ltd
Octopus Publishing Group
Carmelite House
50 Victoria Embankment
London, EC4Y 0DZ
www.octopusbooks.co.uk
www.octopusbooksusa.com

Distributed in the US by Hachette Book Group
1290 Avenue of the Americas, 4th & 5th Floors
New York, NY 10104

Distributed in Canada by Canadian Manda Group
664 Annette St, Toronto, Ontario, Canada M6S2C8

Publisher: Alison Starling
Commissioning Editor: Ellie Corbett
Managing Editor: Rachel Silverlight
Editorial Assistant: Ellen Sleath
Art Director: Ben Gardiner
Design: Eleanor Ridsdale
Production Controller: Emily Noto

ISBN 978-1-78157-920-6

A CIP catalogue record for this book
is available from the British Library

Printed and bound in China

10 9 8 7 6 5 4 3 2 1

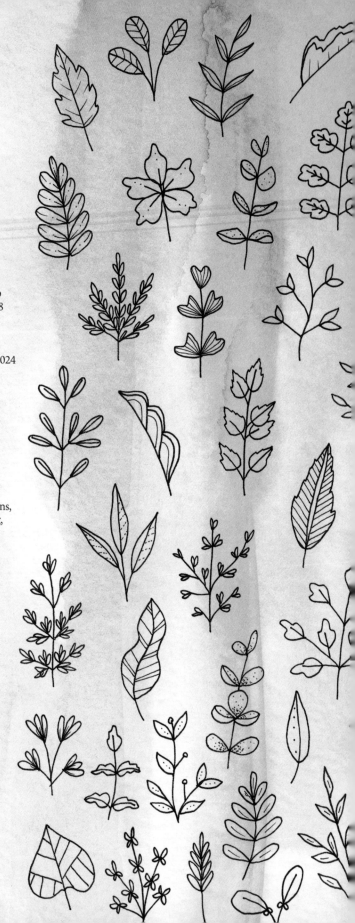

Contents

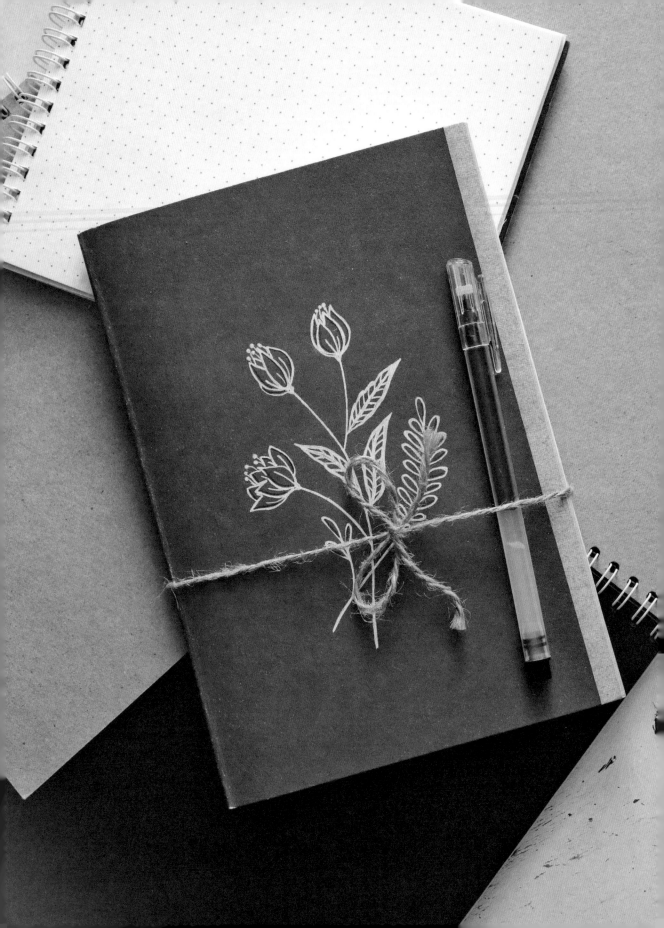

An introduction to mindful drawing

Give your brain the space it needs to better process your thoughts and unwind.

Why draw?

At the end of a long busy day, I know it's tempting to sit down in front of the TV or mindlessly scroll on social media for a few hours. But these things only distract you temporarily rather than actually help you wind down, and you can end up going to bed with to-do lists, conversations and stressful thoughts still whizzing around your head. This is where a creative self-care activity such as drawing can help, as it gives your brain the space it needs to better process your thoughts and unwind.

Drawing or doodling is an enjoyable and satisfying self-care exercise that is accessible for anyone to learn, even if you don't think you are 'creative' or 'arty'. It gives you the chance to do something for yourself, away from a screen, and the repetitive, rhythmic motions of drawing are proven to activate relaxation and reduce anxiety.

Why flowers?

I love doodling flowers as they are so familiar. Inspiration for your next sketch can be found outside your front door, in a patterned fabric, or on your phone's camera roll. No flower is perfect in nature, so you also have total freedom to experiment and make mistakes. Flower drawings can also be quite quick to create, making them easy to pick up and put down, and they include repetitive shapes that can help your mind to relax.

Simple floral drawing is ideal for anyone looking for a new creative hobby: all you need is a pencil, pen and paper, and five or ten spare minutes. Doodling at its essence is simply making marks on the page with a variety of lines, dots and curves, so even if you don't think you are good at drawing or lack creativity, this book will help you learn to doodle flowers with minimal stress or difficulty.

Creating a mindful practice

As with any self-care practice, you'll get the most benefit from your time drawing if you try to:

- Choose a time when you can be quiet and distraction free, for example 15 minutes during your lunch hour or after dinner.

- Set up your environment to be as calming as possible, just as you would do when taking a relaxing bath. Light a candle, pour yourself a drink, turn off your screens and put on some soothing music.

- Listen to yourself and do whatever feels good for you. Drawing should feel comfortable to you, so do it in your own way and really enjoy getting lost in it!

- Remain focused on what you are doing right now – the movement of your pen on the page, the texture of the paper, how the pen feels in your hand, what mark you might make. Try not to think about whether your drawing looks good – at the beginning, you'll take the most joy and benefit from the process itself and, in time, your drawings are bound to improve.

- Remember, these drawings are just for you. If you make a mistake, don't beat yourself up – just finish off your piece, and then start again fresh on your next flower.

Using this book

Before you start

First of all, you CAN draw! Anyone can learn to do this. You'll start with the very basics – a few lines, circles and dots – and you'll soon be creating real magic on your page.

Before you dive into the book, let's put pen to paper straight away. I don't mean to throw you in at the deep end, but try to draw one simple flower to begin with. Anything that comes to mind is absolutely fine – try not to overthink it.

Once you've worked through the book, I suggest that you come back to this page to draw another flower, so you can see just how far you have come.

Tips for using this book

- If you're a total beginner, start with the simple step-by-step tutorials, then, as you gain in confidence, try some of the more challenging projects or alternative ideas.

- I recommend working in pencil first, then going over the pencil marks in pen and finally erasing the pencil when you're happy with how it looks. This applies to every tutorial in the book.

- The projects in Chapter Four become progressively more difficult, so, although you can do them in any order, you'll find the more straightforward ones are at the beginning of the chapter.

- You'll find suggestions for practical uses for each project, but don't be afraid to get creative and make up your own!

- Each project also has a time estimate to give you an idea of how long it might take to complete. This is very much a guideline; everyone works at a different pace, so this isn't a suggestion of how long it 'should' take, but purely an indication of how much time one project might need in comparison to another

- You can download templates to help you with the projects in the book and get more doodling tips on my website, **www.magicofflorals.com**, and find lots more floral art inspiration on my Instagram account **@MagicOfFlorals**!

Materials

One of the best things about simple drawing and doodling is how accessible it is. You don't need fancy pens or equipment to give it a go; I started with a cheap notebook and a Biro. However, for my fellow stationery lovers who can't get enough of nice pens and paper, here are the basic materials I now use to doodle with every day:

Pencils

I always sketch out my drawings first, using a mechanical pencil as it allows me to make fine, light sketches, and as an added bonus, it doesn't need sharpening. I use the Staedtler Mars Micro pencil in 0.5mm, but any pencil you have is fine as long as it doesn't smudge too much.

Eraser

Any white eraser will do the job, but I use standard Staedtler Mars Plastic ones. Remember to clean your eraser regularly to avoid smudging; rub it on your desk or sketchbook until all the pencil has disappeared, leaving it nice and white again.

Pens

I recommend using fine liner pens for doodling, and my favourite is the Faber Castell Ecco Pigment fine liner pen in a 0.3 nib size, as it leaves such a smooth, black line on the paper. You can also use your favourite gel or ballpoint pens if you like. If you want to add detailed line shading, try a smaller 0.05 nib.

Paper

For my daily doodles, I draw in a sketchbook. It's easy to carry with me and it keeps everything together, which is great for seeing my progress over time. If you want to invest in a sketchbook, I'd recommend one with smooth, thick pages, as paper with texture is harder to draw on. You can, of course, also draw on regular printer paper.

Non-essentials

I also occasionally use a ruler, a circle maker and a compass, but these aren't essential.

Digital

Digital media can open up whole new possibilities for your artworks, and many of the drawings in this book have been made in this way. My go-to tools for digital drawing are the Procreate app and an Apple pencil, which I use to draw on my iPad.

Adding colour

Don't be afraid to play around with watercolour paints, coloured pencils, metallic pens, pastels and gouache paint. If you want to try drawing on coloured or black paper, I'd suggest using the Sakura White Jelly Roll Pen.

My favourite way of adding colour is with brush pens – these are water-based markers which you can blend to achieve a watercolour look with more control than with a brush and with the familiarity of using a pen.

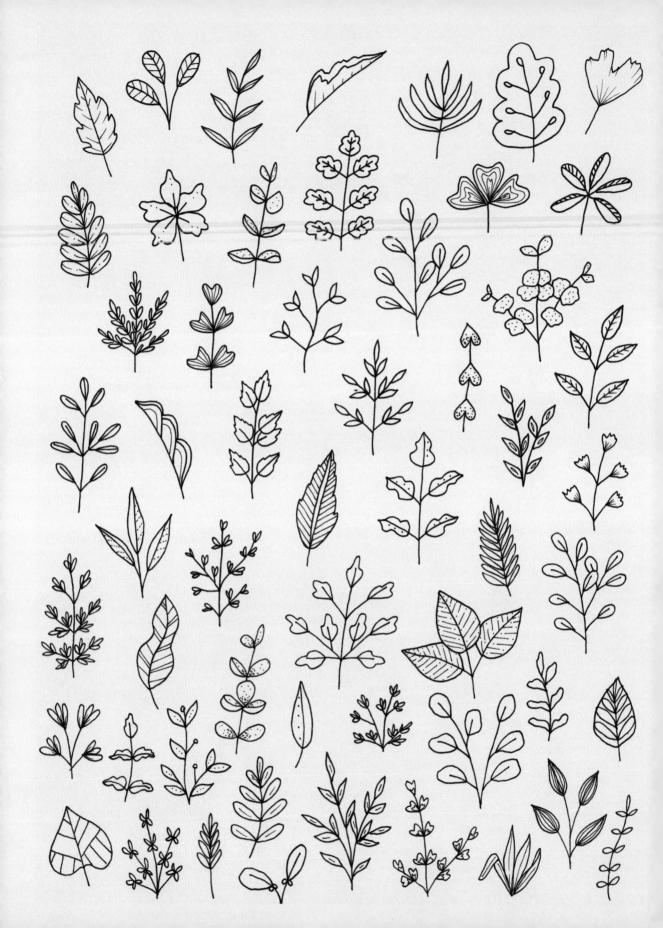

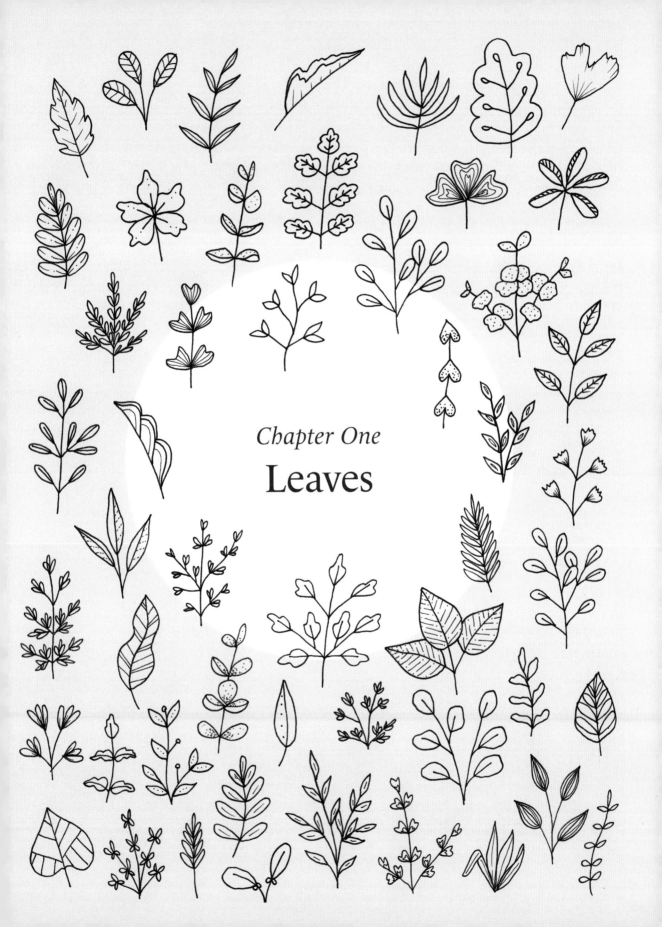

Chapter One

Leaves

An introduction to leaves

Drawing leaves is an ideal starting point and an excellent warm-up exercise to allow you to explore nature's intricacies and express your creativity.

Their simple, serene shapes make them a soothing and versatile introductory subject, good for decorating a journal or enhancing lettering. They also breathe life into your flower doodles, making them invaluable for filling space and introducing striking contrasts within your drawings.

To begin, take a look at some real leaves – notice how their shapes and textures vary widely – and choose a leaf to draw. Observe your leaf and pay attention to the main elements labelled below. Start with a light pencil sketch to capture the overall shape and proportion. Once you are happy with the outline, add details such as the vein patterns, shading and colour. I prefer to keep my leaves simple, but how detailed and realistic you choose to make yours is entirely up to you!

The following pages contain step-by-step tutorials for drawing some basic leaf shapes, as well as tips for using the fundamental elements of a leaf as inspiration to create your own unique designs.

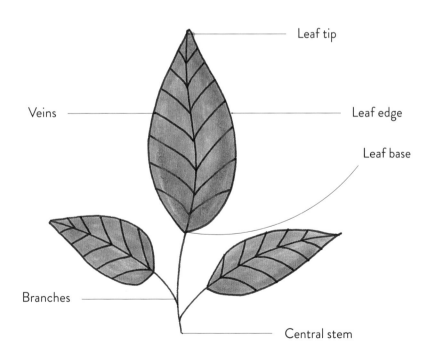

Leaf tip

Veins

Leaf edge

Leaf base

Branches

Central stem

How to draw leaves

Here are step-by-step guides for the ten leaf shapes I use most often. Some are based on actual leaves while others are slightly more abstract.

Leaf A

 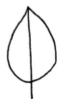 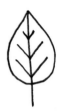

Leaf B

Leaf A (elliptical)

1 Draw a line or central stem.

2 Leaving a small section of stem at the bottom, take a curved line out then back in to meet the top of the stem then mirror this on the other side to form a point at the top and a curved base at the bottom.

3 Add some simple vein lines for detail.

Leaf B (jagged)

1 Draw a line or central stem.

2 Draw a U-shaped curve a third of the way up the stem.

3 Connect the edge of the U to the top of the central stem with a zigzag and mirror this on the other side to form a point at the top.

Leaf C

Leaf D

Leaf E

Leaf C (oblong)

1 Draw a line or central stem.

2 From a third of the way up take a curved line up and over the top to meet back at a point on the other side to form an oval-shaped leaf with the point at the base and a rounded tip at the top.

Leaf D (lobbed)

1 Draw a line or central stem.

2 Draw little V-shaped branches along the central stem at an equal distance apart.

3 Outline your leaf by drawing around the V shapes, over the top of the stem and then back down the other side to meet back at the same point on the other side of the leaf.

Leaf E (heart-shaped)

1 Draw a line or central stem.

2 Take a curved line up and over the top of the stem in a loose heart shape to meet back at the same point on the other side to form the leaf base.

Leaf F

Leaf G

Leaf H

Leaf F (egg-shaped)

1 Draw a line or central stem.

2 Draw a curved line on one side which is rounded at the bottom and top of the leaf, but slightly more pointed towards the top.

3 Mirror this on the other side to form an egg-shaped leaf.

Leaf G (dipped)

1 Draw a central stem.

2 From a third of the way up the stem take a curved line up and out before coming back in slightly to go over the top of the stem to form a small humped leaf tip. Go back out again as you curve back to a point on the other side to form the leaf base.

Leaf H (ivy)

1 Draw a central stem.

2 From a third of the way up, take a curved line down and up to the top of the stem. Mirror this on the other side to form a point at the leaf tip and wide edges with a small point at the base.

Leaf I

 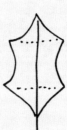 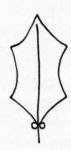

Leaf J

Leaf I (holly)

1 Draw a central stem or line with two horizontal lines the same width across in pencil.

2 From the central stem draw a slightly inverted line up to a point at the end of the first horizontal line, then across to the next line point with a curve before finishing at the leaf tip with a point. It will almost look like a sideways M shape with each end pulled outwards.

3 Mirror this on the other side to form a holly leaf.

4 Add some berries then erase the pencil marks.

Leaf J (eucalyptus)

1 Draw a central stem in pencil.

2 Add two small teardrop shapes on the top of the stem.

3 Add small cloud-like shapes to either side of and across the central stem in little clusters to look like eucalyptus.

4 Go over in pen then erase the pencil marks to remove the stem line going through the leaf centres.

How to add variety

Adding variety to your leaf drawings can make your artwork more diverse and engaging.

Get creative with different leaf shapes, techniques, styles and details. For example, you could play with colour schemes, combine leaves with other natural elements, add shadows to give them dimension or use different media to add depth and texture. Here are my top five things to consider when adding variety to leaves:

1. Can you alter the proportions of your leaves?

Play with the width and length of your leaves. Small, thin leaves will look very different from a stem of wider, bigger leaves, even if they're the same shape. Do the leaves on your stem change in size, perhaps?

You can also experiment with their spacing along the stem. For example, try adding lots of leaves tightly packed together on a branch versus ones which are more spaced out or that get progressively bigger as you work your way down the stem.

Leaf size

Spacing

2. How are your leaves arranged?

Are the leaves directly opposite each other on the stem (an opposite leaf arrangement)? Do they alternate or are they in groups (whorled)? Do they have little branches coming off the central stem or do they sit straight on the main stem?

Overlapping your leaves and tucking leaves behind other ones will give a much more natural look. It really helps to work in pencil first if you want to do this.

Off the stem

Off branches

Overlapping

3. How are your leaves positioned?

When adding leaves to flower drawings there are plenty of options when deciding how to position them. We'll cover a little more on drawing natural-looking arrangements, but for simple blooms, here are a few variations to try:

On blooms

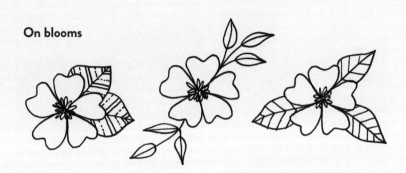

On stems

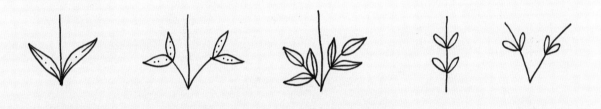

On branches

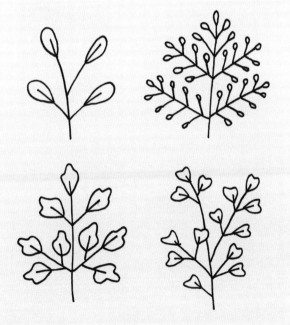

4. What veining or shading would elevate your leaves?

You can add interest to your leaves and make them look different just by changing the veining or shading details you use. For example, shading in one side of the leaf only will add more contrast and adding tighter veins will add more pattern.

Veining

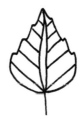 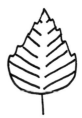 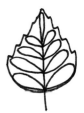

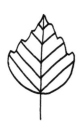 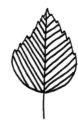 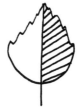 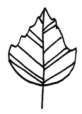 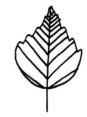

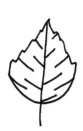 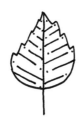 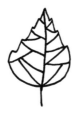 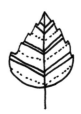

Shading

TIP

Using a smaller-nibbed pen (such as a 0.05) makes adding neat shading much easier. Try to flick your pen outwards as you shade, relieving the pressure as you lift of the page.

5. How about adding perspective?

You can absolutely keep your leaves simple and two-dimensional (I do most of the time), but if you want to add some perspective to your drawings, then adding curls and bends to your leaves is a good way to achieve this.

Curls and bends

To add curls, simply add a smaller curved line to the edge of your leaf to give the impression it is 'curling' up towards you or twisting slightly.

To add bends to your leaves, start with the same curved line then adjust the edges of your leaves to make it look like it's bending in, over or away from you.

If your leaf is more of an oval shape, adding another curved line to the inside edge of one side can give them impression the leaf is curved down or up, in a bowl shape.

Flat

Curved down

Curved up

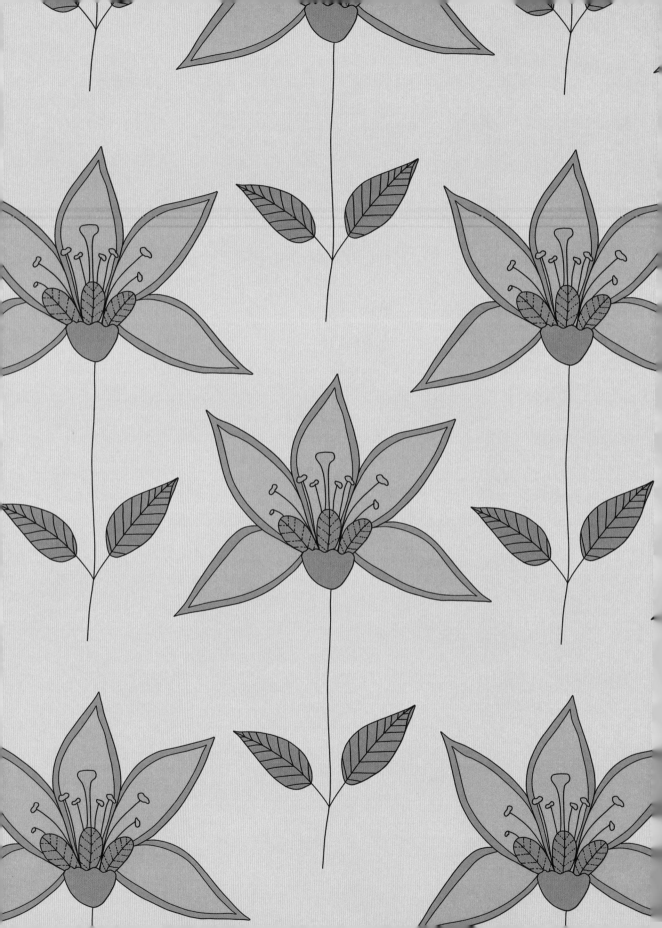

Chapter Two
Flower Stems

An introduction to flower stems

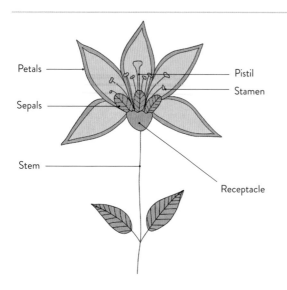

Petals

Sepals

Stem

Pistil

Stamen

Receptacle

This chapter focuses on 2D flower stems or side profile views. For each flower you'll find two step-by-step examples – a simple version and an upgraded version. There's also ideas for varying the design and a 'transformer' to show you how you can turn each one into a totally different flower by making just a few small tweaks.

How to draw any flower

To start drawing a flower stem, simplify the overall shape as much as possible, for example a circle or a bell shape. Next, divide this shape into segments to represent the petals, usually around five or six works well. These segments can be elongated teardrops or rounded triangles, depending on the flower you are doodling. Add curving lines to give the petals a natural look and connect the petals to the stem, which can be a straight or slightly curved line. To finish, add leaves along the stem and details to the centre of your flower.

To add more depth and variety, try experimenting with different elements of the flower's anatomy, for example with shapes of the petals, such as heart-shaped, spiky or asymmetric ones. Play with the size and arrangement of the petals to give your doodles a distinct character. Additionally, explore different flower centre designs, like circular patterns, dots or even spirals. As we explored in the previous chapter, you can also vary the shapes and sizes, and add details and shading to your doodles for added realism and depth. Embracing these elements allows you to unleash your creativity and craft a wider array of unique flower doodles.

 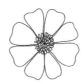 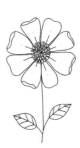

Stems

Is the flower stem upright or does it droop over? Will the stem have extra branches with more flowers, or is it a single bloom?

Receptacles and sepals

Does the flower have a receptacle or any sepals joining the petals to the stem? Are these small or large? What shape are they?

Petal shapes

What shape are the petals? Are they long or short, thin or wide? How are they arranged? For example, are they in a single layer positioned next to each other or do they overlap or form layers? Does adding more or fewer petals give your stem a new look?

Details

What details do you want
to include? Do you want to
add any stamens, shading
or patterns?

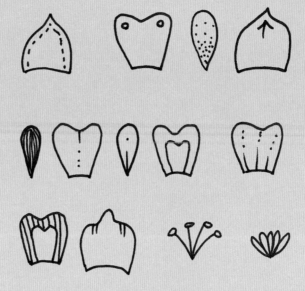

Leaf position

Where are the leaves positioned
on the flower stem, and what
shape works best?

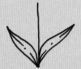 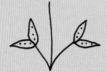 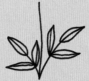

TIP

If it helps, you can print off photos of flowers and then try sketching
out their outline shape with a coloured pen on top of the image.
Tracing flowers and their petal shapes like this is also a good way
to build up muscle memory.

Basic flower shapes

Bowl
Buttercup or poppy

 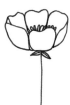

Trumpet
Morning glory or amaryllis

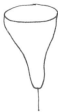 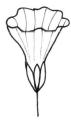

Cup
Crocus or tulip

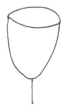 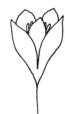

Bell
Canterbury bells or heather

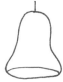 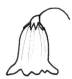

Tubular
Trumpet honeysuckle or aloe

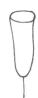 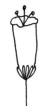

Bell heather

These super-simple bell-shaped flowers are great for adding variety to your doodles among the more common flower petals and leaves. Bell heather is a wild, summer flower that grows along the coast and in woods and heathlands. Its flowers are a dark pink-purple colour arranged in clusters up the stem, and it has short, dark green, needle-like leaves.

Simple

1 Draw a line to form the central stem.

2 Add short curves out from the stem all the way down – I like to make these a bit random to give it a more natural look, but you could draw them symmetrically if you wish.

3 Add little bell shapes (simply a U with an oval on the top) to the tops of the curved lines.

4 Finish with decoration such as little lines.

Upgrade

1 Draw a line to form the central stem.

2 Add little bell shapes to the top of the stem coming from little branches at random, as for the Simple version.

3 Add more bells in small clusters as you work down the stem.

4 Add some details, leaves or colour to the bells to complete your doodle.

More ideas to try

- Try adding branches coming from the central stem with even smaller branches coming from them to give a fuller look.

- Play around with adding leaves and smaller details such as dots instead of lines.

- Add different stamens or 'tops' to each bell.

- Angle the bells downwards as well as upwards.

Transformer

Change the angle of the upright stem to droop over then add the bell shape to form a poppy bud. Add a simple flower and leaf to transform the bud into a poppy (one of the birth flowers for August, see page 141).

Simple

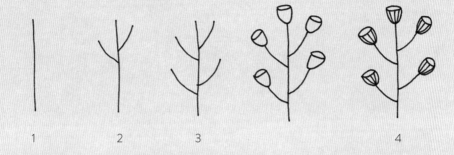

1 2 3 4

Upgrade

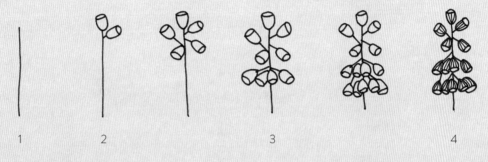

1 2 3 4

More ideas to try

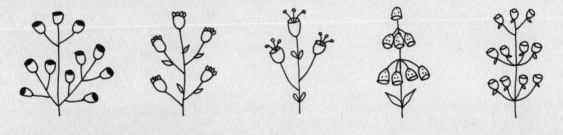

Transformation into a poppy

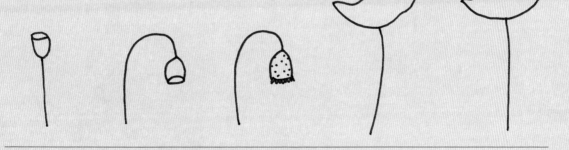

Simple

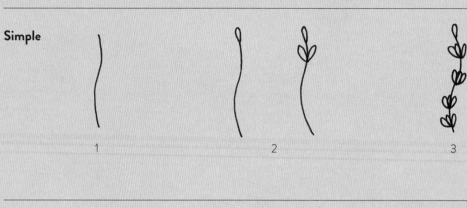

1 2 3

Upgrade

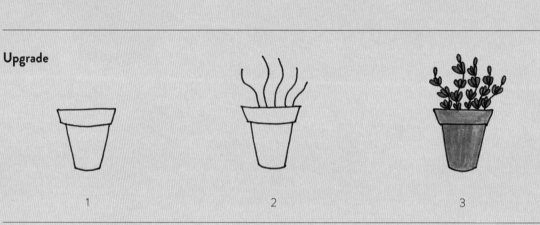

1 2 3

More ideas to try

Transformation into a larkspur

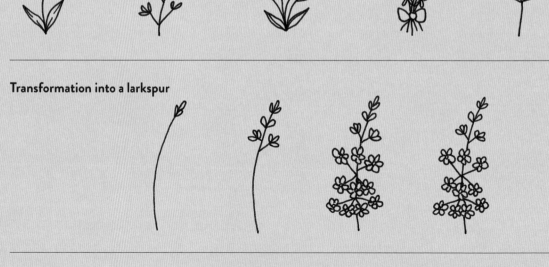

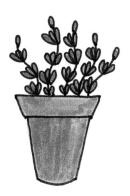

Lavender

Lavender is super simple to doodle, adds great variety to floral compositions and is a good space filler. This fragrant herb grows on upright stems with tiny little flowers arranged at the top to form a shrub-like plant. The flowers are usually a deep blue-purple with long, thin grey-green leaves.

Simple

1 Draw a line to form the central stem – a curved or wiggly line will look more authentic.

2 Add a small teardrop shape to the top of the stem.

3 Add more teardrops down the stem in clusters of two, three or four.

Upgrade

1 Draw a simple plant pot (or trace this one).

2 Add four or five wiggly stems coming from the pot.

3 Add teardrop shapes down the stems in clusters, leaving small gaps occasionally for a more natural look.

More ideas to try

- Draw upside-down teardrop shapes in rows down the central stem, getting wider as you go down.

- Add small branches down the central stem then add two or three teardrop shapes at the end of each one.

- Add more teardrops down the stem and underneath to form small butterfly-like shapes.

- Draw teardrops horizontally or change their shape to form little hearts.

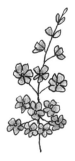

Transformer

Instead of teardrop shapes add little clusters of tiny flowers down the stem, adding more width as you work towards the base to draw a larkspur (one of the birth flowers for July, see page 141).

Simple

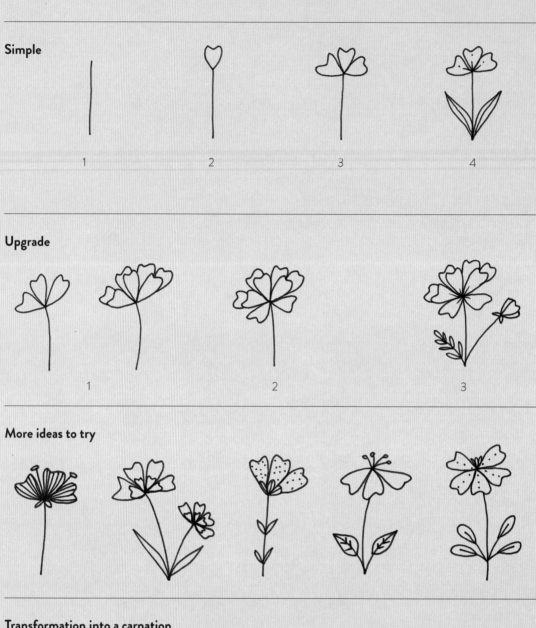

1 2 3 4

Upgrade

1 2 3

More ideas to try

Transformation into a carnation

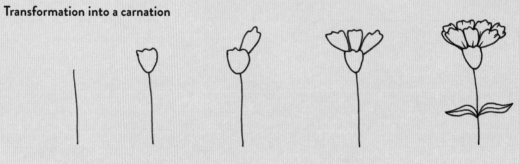

Cosmos

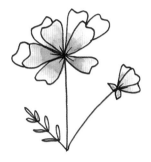

These heart-shaped petal flowers are loosely based on a cosmos flower and must be my most doodled floral stem. I use them in almost every project, and there are lots of ways you can vary them. Cosmos are colourful flowers that sit on long, slender stems and bloom in the summer, so they are popular with bees, butterflies and birds. They have white, pink, purple, red, orange or yellow petals, with bright yellow centres, and their leaves are dark green, narrow and pointed and grow in pairs, opposite each other on little stems.

Simple

1. Draw a line to form the central stem.

2. At the top of the stem add a heart-shaped petal.

3. Add more heart shapes either side of the first one.

4. Finish by adding detail to the petals and a few leaves, if you like.

Upgrade

1. Draw the simple flower as above then add a second layer of petals peeping out from behind the first set.

2. Add two more heart-shaped petals to the base of the flower to look like they have fallen down towards you to form a fuller head of petals.

3. Add leaves and a bud before finishing with a few shading lines.

More ideas to try

- Experiment with adding different details to the petals to change up the look (adding little lines like I've done here is super relaxing).

- Add more heart shapes to the top of the stem so your flower has four or five petals instead of three.

- Add details such as receptacles, leaves or a stamen.

- Add petals pointing downwards rather than upwards and add different little stamens to the top.

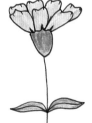

Transformer

Add a large cup-shaped receptacle to the central stem then add petals with a slight wiggle to the petal tips to make them look more 'ruffly'. Add another layer of petals behind and some leaves halfway down the stem to turn your cosmos into a carnation (one of January's birth flowers, see page 140).

Simple

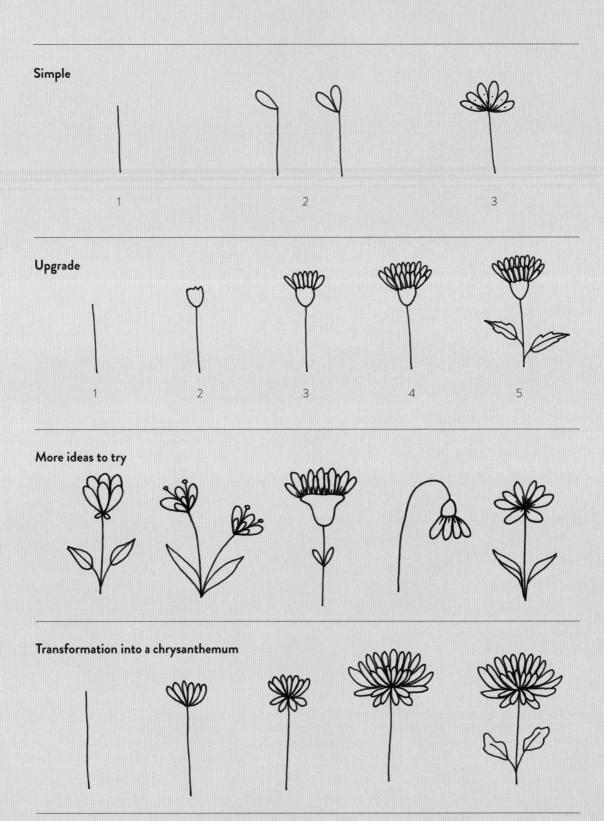

1

2

3

Upgrade

1

2

3

4

5

More ideas to try

Transformation into a chrysanthemum

Aster

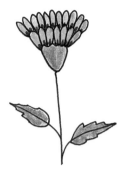

Asters are members of the daisy family and tend to grow in late summer and autumn. They are notable for their starburst arrangement of bright petals around a yellow centre and are commonly found in white, purple, blue or pink. They have long, skinny green leaves. Asters are one of the birth flowers for September (see page 141) and symbolize love, wisdom and faith.

Simple

1 Draw a line to form the central stem.

2 Draw a teardrop-shaped petal at the top of the stem.

3 Add more petals and add some line details to finish.

Upgrade

1 Draw a line to form the central stem.

2 At the top add a receptacle with a wavy top.

3 Add thin teardrop-shaped petals coming from the top of the receptacle.

4 Add another layer of petals behind the first set.

5 Finish by adding some leaves.

More ideas to try

- Add smaller or larger receptacles.

- Draw the stem drooping over rather than upright.

- Draw petals angled down underneath as well as facing upwards.

- Play around with adding stamens, different leaves and differently layered petals.

Transformer

Draw a small set of long thin petals on top of the central stem, then add a small layer falling down at the front. Add more petals in a second layer all the way around, curving them slightly to turn your aster into a chrysanthemum (One of November's birth flowers, see page 141).

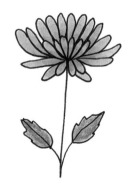

Simple

 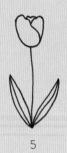

1 2 3 4 5

Upgrade (fuchsia)

 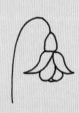 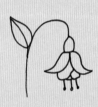

1 2 3 4 5

More ideas to try

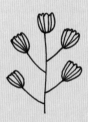 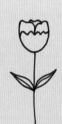 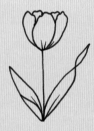

Transformation into a lily of the valley

 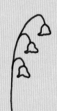 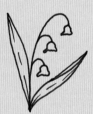

Tulip

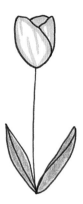

Tulips are classic spring flowers that usually grow in warm colours such as red, pink, yellow or white. They have two or three long, thick green leaves which are clustered at the bottom of the stem and they tend to bend and curl. Tulips are associated with unconditional love.

Simple

1 Draw a line to form the central stem.

2 At the top of the stem add a U shape.

3 Bring down one side of the U diagonally with a curved line across to finish near the bottom of the opposite side.

4 Bring down the other side of the U to meet the first petal.

5 Finish by adding a tiny petal across the top then some leaves and shading, if you like.

Upgrade (fuchsia)

1 Draw a curved line that droops over to form a central stem.

2 At the top of the stem, draw a small, rounded cone-shaped receptacle.

3 Draw two petals curling out to a point and slightly upwards at the ends.

4 Add two more petals in the middle as for the top of the tulip.

5 Add a couple of stamens dangling down and a leaf to finish.

More ideas to try

- Simplify your tulip head even more by drawing a U shape with a wiggly top and adding a few more tulip flower heads to the stem.

- Add stamen coming from the top of the flower.

- Droop the stem and flower head down rather than drawing them upright.

- Add a few more petals as if the tulip is opening up.

Transformer

Add three small bell-shaped flower heads hanging from a droopy stem and two large leaves to make a lily of the valley (one of May's birth flowers, see page 140).

Simple

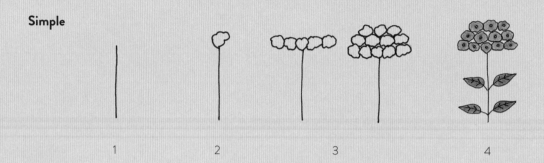

1 2 3 4

Upgrade

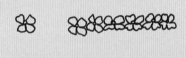

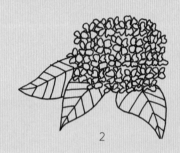

1 2

More ideas to try

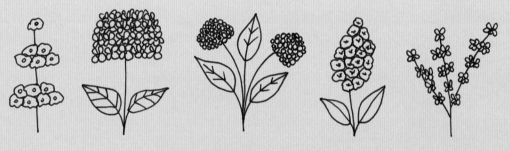

Transformation into a hyacinth

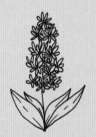

Hydrangea

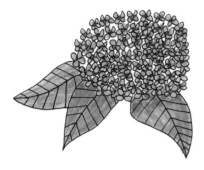

Hydrangeas are associated with gratitude and grow in a range of colours including white, blue, red, pink and purple. Their petals can actually change colour depending on the soil they're in, turning blue-purple when the soil is acidic and pink when it's alkaline. Hydrangeas have large, bright green leaves with jagged edges that grow underneath the flower heads.

Simple

1 Draw a line to form the central stem.

2 At the top of the stem add a very loose and wiggly circle to form the first little flower head.

3 Add more small flowers in a line across, then build upwards with the lines of flowers getting progressively smaller.

4 Finish by adding small circles to the centre of each flower and some leaves.

Upgrade

1 Draw a cluster of simple four-petalled flowers in a circle (don't worry about perfection here – this needs to look natural).

2 Add larger leaves from the bottom of the flower head.

More ideas to try

• Add flowers to the stem at different levels rather than in a ball at the top.

• Add the small four-petalled flowers as for the Upgrade to the stems as well.

• Add little balls to the top of the stems to give a simplified hydrangea look with large leaves.

• Draw a leaf shape in pencil then fill it with small loose flowers to resemble a lilac.

• Add tiny flowers in clusters to the stems instead of in a ball shape.

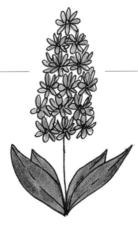

Transformer

Add small flower heads with pointed petals down the stem rather than in a ball at the top. Add four long pointed leaves to turn your hydrangea into a hyacinth.

Simple (calla lily)

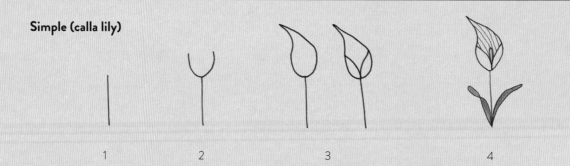

1 2 3 4

Upgrade

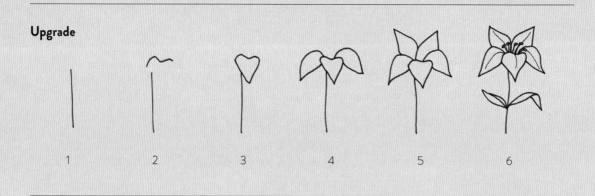

1 2 3 4 5 6

More ideas to try

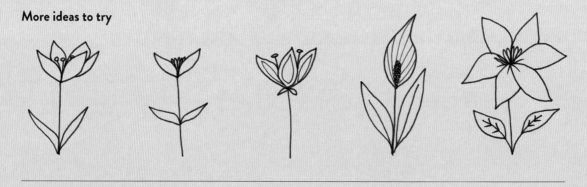

Transformation into a water lily

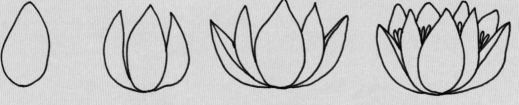

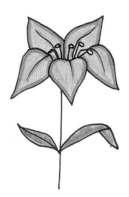

Lily

Lilies are popular, colourful and fragrant flowers that usually bloom in summer. Their star-shaped flower heads typically have six petals in pink, yellow, red, orange or white and stamens with burnt-orange pollen heads. Their leaves are long, narrow and dark green and tend to grow along the length of the stem.

Simple (calla lily)

1 Draw a line to form the central stem.

2 Add a large U shape to the top of the central stem.

3 Bring the two sides to meet in a point above the U and slightly over to one side.

4 Add curves from the base of the U shape out to the top of the U to form the front of the calla lily then finish with a single stamen to the centre and some leaves.

Upgrade

1 Draw a line to form the central stem.

2 Draw a wiggly line above the central stem to form the base of the first petal.

3 Finish the first petal by bringing the two sides to meet down in a point slightly to one side of the stem.

4 Add more petals on both sides of the first petal.

5 Draw two more pointy petals at the back to complete the lily flower shape.

6 Add the stamen by drawing lines from the centre of the flower with little oval shapes on the end.

More ideas to try

1 To doodle a lily just opening up, draw all of the petals pointing upwards instead of the front few folding over.

2 For a more abstract lily simplify the design by adding three pointy petal shapes with stamens in between and little sepals underneath.

3 To draw a peace lily, draw a calla lily as in the Simple version but don't draw the front curves on – instead add tiny circles to the stamen.

4 Add more petals in a star shape to draw a more top-down view.

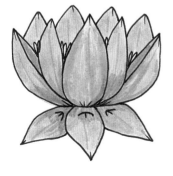

Transformer

Start with a large, pointed petal then add two more petals on either side, the outer ones with an extra curve on the inside edge to make them look like they are curling in. Add another row of petals behind then add centre stamens peeking through and more petals falling down at the front to form a water lily (a birth flower for July, see page 140).

Simple

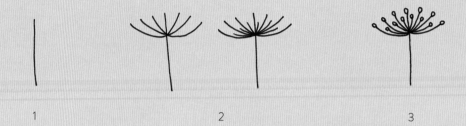

1 2 3

Upgrade

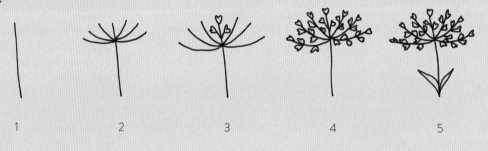

1 2 3 4 5

More ideas to try

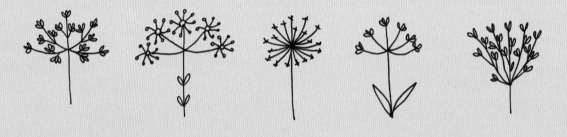

Transformation into Queen Anne's lace

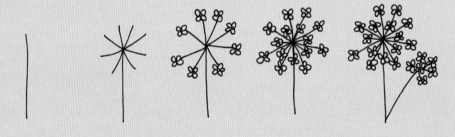

Baby's breath

Baby's breath, or gypsophila, grows in large sprays of flowers on branching stems and the flowers usually have white or pale pink petals. It is often used as a filler flower for bouquets and is very popular at weddings as it represents purity and innocence. It has small, narrow, grey-green leaves and tends to bloom in summer.

Simple

1 Draw a line to form the central stem.

2 Add little curved lines to form a bowl shape at the top of the stem, varying the lengths slightly.

3 Add small circles to the end of each one to form the 'spray'.

Upgrade

1 Draw a line to form the central stem.

2 Add short lines to the stem, curving out to form a bowl shape as above.

3 Add little heart-shaped petals or buds to the top of the stem, and to each of the curved lines at the top and along the branches.

4 Repeat until each branch is full, adding as many petals as you like. The petals might sit directly on the branch or have little branches of their own.

5 Add simple leaves to the bottom of the central stem.

More ideas to try

• Experiment with different petal and leaf shapes within the same basic shape of the baby's breath flower head.

• Instead of adding leaves coming off the central stem, draw smaller flower heads on one or both sides.

• Add more curved branches along the bottom to form a full head or circle of petals.

• Make the branches longer to make the bowl shape much deeper.

Transformer

Draw a full circle of curved branches at the top of the stem then add small flowers to the ends. Repeat with shorter, curved branches between each longer one to form an inner circle to turn your gypsophila into Queen Anne's lace.

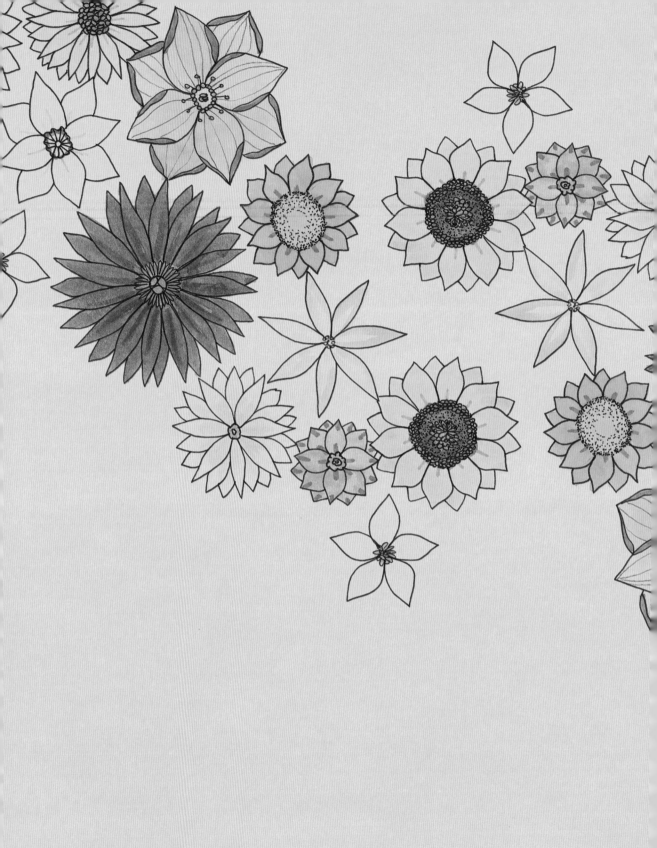

Chapter Three
Flower Heads

An introduction to flower heads

This chapter is all about big, open blooms and how to add depth and perspective to your flowers for more complexity. Of course, you can absolutely draw all your flowers 'flat' if you prefer to keep it simple.

Whether you're using reference photos or real-life flowers to draw from, my advice is to simplify, simplify and then simplify again. Start by observing closely and begin with the basic shapes in pencil – the flower centre and its rough outline – then you can refine the shape of the petals, paying attention to their size, curvature, and whether they overlap or have gaps between them or curl. Once you are happy with this stage, you can add extra details such as the stem and leaves, shading or colour, according to your own style and preferences.

How to draw flower heads

As you get to grips with drawing flower heads, here are some factors to think about:

Petals

How many petals does your flower have, and what shape are they? Are they arranged next to each other or in layers? I often use little markers around the flower's centre to help guide the positioning of the petals.

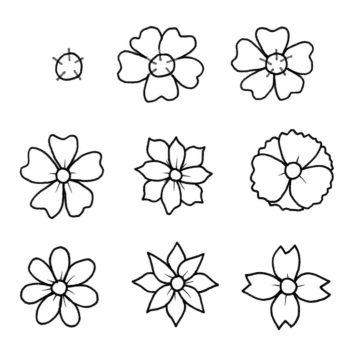

Adding folds to petals will make a huge difference and make your flower look much more organic. By simply adding curved lines along the inside edges of your petals you can make them look like they're curling at the tip or in at the sides, which will give your flowers more perspective and movement. Here are some examples to experiment with.

Folds

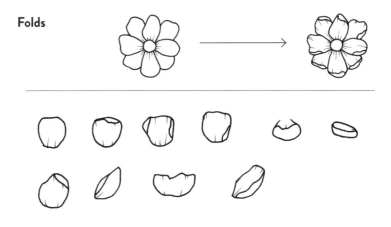

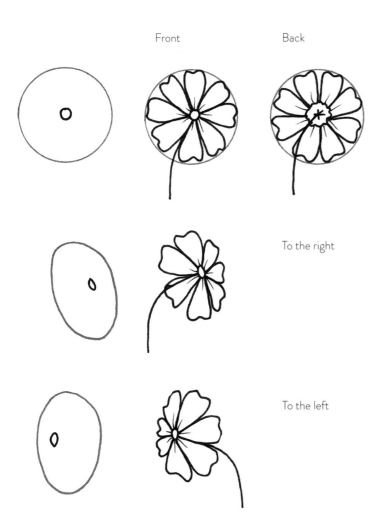

Front

Back

To the right

To the left

Different angles or directions

When drawing a fully open flower head sketching a guide circle will help you keep all your petals roughly the same length. However, if you want to draw the flower from an angle or a slightly altered perspective, transform the circular guide into an ellipse and adjust the positioning of the flower centre accordingly. This will make it easier to visualize where to elongate or shorten the petals, creating the illusion of a shifted angle or viewpoint.

Marking the petals' position is especially helpful when the perspective changes. The altered appearance of the petals can present a challenge, so I recommend honing your skills by beginning with a simple five- or six-petal flower. Once you've gained confidence, you can progressively tackle more intricate flower heads and master the art of drawing flowers from various perspectives.

Stages of flower opening

Exploring the different stages of a flower opening, from the tightly wrapped bud to the splendid full bloom, adds another layer of beauty and realism to your floral drawings. As with the basic flower head, the key lies in recognizing and sketching the fundamental shape before detailing the petals. Let's delve into the process:

1 The closed bud begins with an oval shape, which you can make taller or wider depending on the flower you are drawing. Then add sepals, a receptacle and a stem. Draw an elongated S shape down the middle of the oval to emulate the tightly wrapped petals.

2 As the petals begin to unfurl, most of the flower's inner components and centre remain concealed, while the sepals and receptacle are still visible.

3 Now the petals are much more open, and the centre becomes visible. Pay attention to the evolving petal shapes and the changing space between them. The sepals may still just be showing from the base of the stem.

4 As the flower comes into bloom, the petals are almost fully extended and the flower's central structure is prominent. The sepals are now hidden. Adding curls to your petals will help add a sense of dimension.

5 In the final stage, the petals are at their full extent, the cup shape becomes more like an umbrella and the flower's centre is displayed in full.

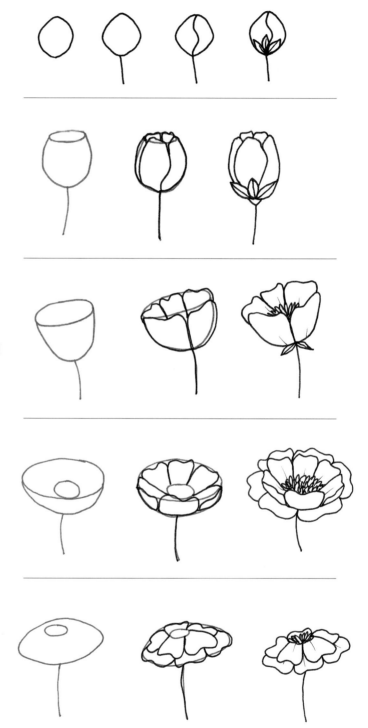

The flower's centre

Adding a more detailed centre to your flowers will add contrast and interest to elevate the flower heads. Here are a few examples made up of a variety of little circles or ovals, scribbles, clusters of stamens, lines or mini flowers. Don't be afraid to get creative and make up your own!

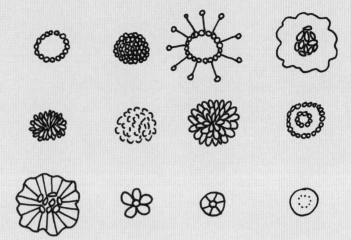

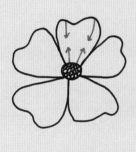

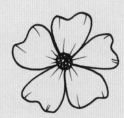

Shading the petals

You can absolutely stick with simple petal line details as we did in Chapter Two, but if you want to add more detailed shading for a more realistic look, this can help give your petals more dimension, movement and contrast.

I'd recommend doing this with a smaller-nibbed pen (such as 0.05) and lifting the pen as you move outwards in a little flicking motion to create small, feathery lines. Follow the shape and direction of the petals and think about where the light and shadow would naturally fall – for example, where the petals meet the centre

will be darker. Lines should always move from the centre out or back towards the centre if you add lines from the edges of your petals inwards – this is particularly effective on either side of a dip or bend of the outer edge of the petal. Adding dots after the lines makes them look like they continue to fade out.

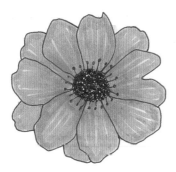

Anemone

Anemones are spring flowers with a mixture of heart-shaped and oval-shaped petals and a distinctive black centre. They grow in a range of colours including white, yellow, pink, purple, red and coral. They symbolize fragility and love and are part of the same family as buttercups.

1 2 3 4

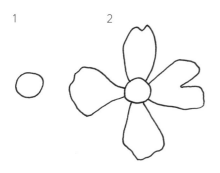
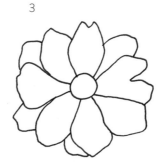
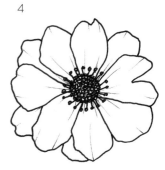

1. Draw a small circle for the flower centre.

2. Add four loosely heart-shaped petals at twelve, three, six and nine o'clock.

3. Add rounder petals in between the original four and a couple poking out from behind until you're happy with how 'full' your flower looks.

4. Fill in the centre circle with tiny circles, then add some stamens (a little line with a circle on top) all the way around this to complete your flower.

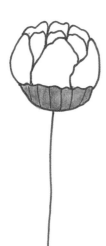

More ideas to try

- Add more or fewer petals to the flower and try drawing it at different stages of its life or from a different angle.

- Experiment with different details in the centres.

- Add folds and/or shading to your petals to make them look more realistic.

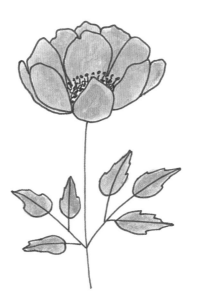

TIP

When drawing any flower, you can play around with different petal shapes from the original and try mixing the shapes within the same flower head, as with the anemone here.

Peony

Peonies are a firm favourite in late spring and early summer. These big fluffy blooms come in a range of gorgeous colours including white, pink, coral, maroon and yellow and symbolize prosperity, good luck, love and honour. Their leaves are elliptical and pointed and tend to be three-pronged.

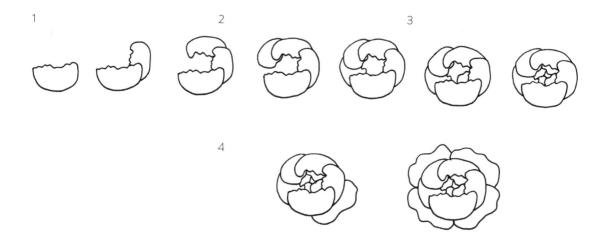

1 Draw a semi-circle with a wavy top to form the first petal.

2 Add more petals overlapping each other slightly as you work around to form a rough circle shape. Don't worry too much about these being symmetrical.

3 Draw smaller wiggly curves inside the petals to form the petals inside the flower head.

4 Draw four to five looser petals around the outside of the peony bud. Wiggle these curves as you go to form imperfect semi-circles. Trace over with a fine liner, then erase your pencil lines.

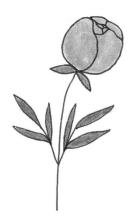

More ideas to try

- Instead of drawing the outer petals of the peony in step 4, you could leave these off the peony bud and add some leaves instead.

- Try drawing the peony opening from a side view. Imagine the petals unfolding slightly to get the right angle in profile.

- To make your peony look fuller and fluffier, add curved lines to the edges of the petals to make them look like they are unfolding at the edges – this is particularly effective on the side-view flowers.

- If you're feeling daunted by the shape, feel free to trace over the examples on these pages and then use those pencil lines as a basis for your own line drawings in ink.

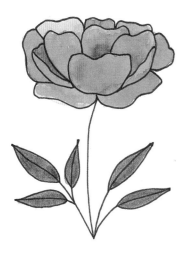

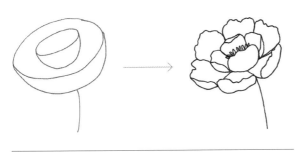

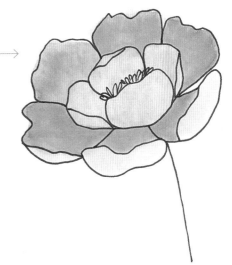

TIP

When drawing a big fluffy bloom like a peony, which has several layers of petals, you can use a 'double bowl' as a guide. These can help suggest where to curl your petals upwards to show their underside.

Marigold

Marigolds are bright and vibrant summer flowers, usually found in shades of yellow, orange and red. They have dark green pointed leaves that grow opposite each other. They symbolize positive energy and, not surprisingly, are associated with the sun.

1 2 3

1 Draw a tiny circle for the centre then add five small, curved petals around it.

2 Keep adding layers of semi-circles around the edge, starting from the middle of a petal to the middle of another until you build out a fluffy-looking flower.

3 I added six layers here, but you can add as many as you like until you're happy with how it looks. Finish by adding a little detail, shading or colour to the petals.

TIP

To keep your petals even and your circle shape consistent try drawing concentric rings in pencil as a guide and turn the page as you progress around the flower.

More ideas to try

- Using different petal shapes, such as a pointed petal, will make your flower look like a dahlia.

- Try drawing the marigold from the side or opening out from a bud.

- Play around with the petals' sizing – for example, try drawing them getting progressively larger.

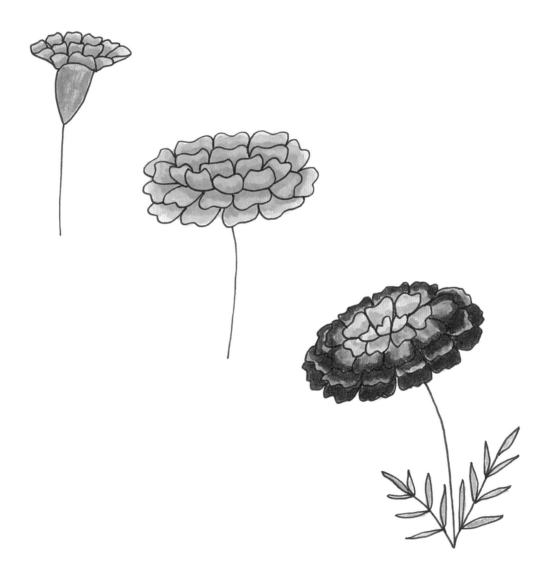

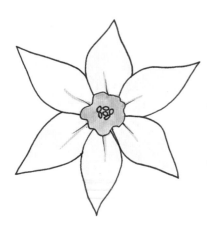

Daffodil

Daffodils are the national flower of Wales and the birth flower for March (see page 140), along with the very similar jonquil flower. They typically have six white or yellow petals surrounding a central trumpet with long, narrow leaves. They symbolize rebirth and hope, which makes sense given they poke their heads out of the snow to signal spring is on its way.

1

2

3

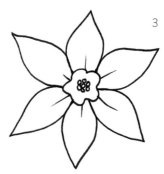

From the front

1 Draw five or six tiny circles to form the flower centre.

2 Draw a wiggly circle around the tiny circles.

3 Add six pointed petals coming out from the centre and finish with a line flicking out from the centre of each petal.

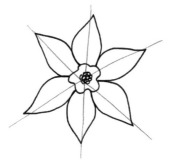

TIP

To get six equally spaced petals, draw guidelines in pencil. Start with a vertical line then a cross that divides each half into three. Draw your petals around each line to form a starburst of six petals.

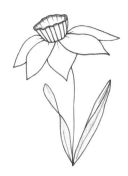

1

2

3

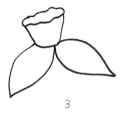

From the side

1 Draw a wiggly oval shape.

2 Draw lines down from this to form a tapered cup or trumpet shape.

3 Add two pointed petals from the base of the trumpet going off to each side.

4 Add the centre petal poking out underneath in between the first two.

5 Add two more petals at either side.

6 Add a stem and some long, twisty leaves.

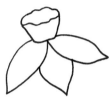

4

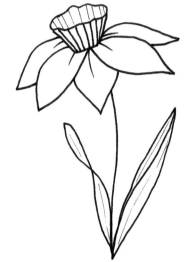

5

6

More ideas to try

- Try drawing different centres or add more detail to your daffodils.

- Draw several small flowers on a single stem to turn your daffodil into a jonquil.

- Try drawing the daffodil as a bud or just opening.

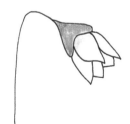

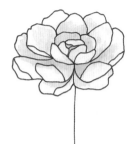

Rose

There are hundreds of varieties of roses and so many different ways to draw them. These beautiful, fragrant flowers are one of the birth flowers for June (see page 140) and commonly grow in red, pink, white, peach and yellow with dark green, jagged-edged leaves.

1

2

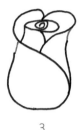
3

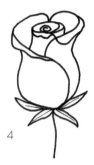
4

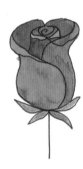

Rose A

1 In pencil draw a deep bowl shape with a spiral at the top.

2 From the centre of the top draw a large S shape going across the bowl and finishing at the bottom of the flower.

3 Add another curve on the opposite side at the top of to meet the S shape to form a heart shape at the top of the flower.

4 Finish by adding smaller curved lines to form curls in the petals, some sepals and a stem.

Rose B

1 Draw a tiny spiral then add three curved petals with a slight dip in the tip around the spiral.

2 Add another three petals around the outer edge and then keep going until you're happy with how full and open your rose is looking. You can vary the shapes of the petals, adding points, for example.

3 Add a couple of large leaves to finish your rose.

1

2

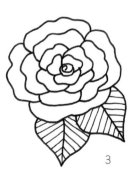
3

Rose C

1 Draw a circle then add two curves inside to form a slightly curved V shape on its side inside the outline.

2 Add more curved lines inside at different angles until you have the effect of petals folded over each other .

3 Draw loose, large petals around the edge and finish by adding leaves.

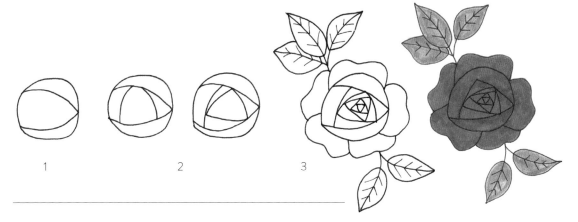

1 2 3

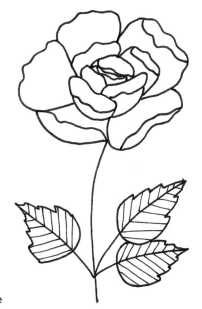

More ideas to try

- Try drawing your rose from the side or as a bud.

- Add lots of petal folds and curls to give your rose more perspective.

- Try different petal shapes and adding several layers of petals.

TIP

Wiggle your pen as you draw the petals – adding little dips to the ends of petals and varying the shapes of any flower will prevent them looking too straight or stiff. Slightly misshapen and uneven petals will make them look more natural and give them more movement.

Daisy

The daisy is one of April's birth flowers (see page 140). A common wildflower, it grows all year round on single stems and has white rounded petals and bright yellow centres. Its leaves grow from the base of the stem and are green and rounded. There are a massive range of daisy species, such as gerberas, which also grow in colours including pink, red, yellow, blue and orange.

| 1 | 2 | 3 | 4 |

1 Draw tiny circles in a cluster to form the daisy's centre.

2 Take loopy oval-shaped petals out from the centre and all the way around the centre.

3 Add more petals peeking out from behind the first layer to fill any gaps.

4 Add a little flick out from the centre on each petal.

TIP

When drawing any flower try experimenting with the spacing of the petals. Leave the occasional gap, make them overlap or just draw the tip peeking out, as this will make them look more natural than if they are all the same and sitting perfectly next to each other.

From the side

1 Start with a simple mound shape for the flower's centre, and fill it with little circles.

2 Add a few petals angled downwards, leaving a little space between them to add a few partially visible petals peeking out from underneath.

3 Add petals until the flower head is filled out, in an umbrella shape.

4 Finish with a stem and leaves, and add a few details and colour, if you like.

1

2

4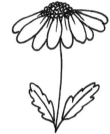

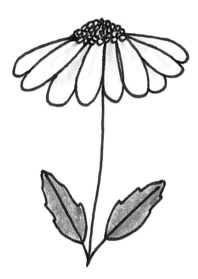

More ideas to try

• Try changing the centres or petal shapes.

• Add smaller daisy heads on little branches coming off the central stem.

• Try drawing your daisy at different stages of opening (see page 50).

Sunflower

Sunflowers have a large circular centre and daisy-like, pointed yellow petals. They grow on tall, hairy stems that can be up to 3m (10ft) tall and have broad, toothed and alternate leaves. They symbolize loyalty and adoration and are well known as being a happy summer flower. They are commonly grown as a crop as their seeds can be eaten or made into cooking oil.

1 Draw two guide circles in pencil then fill the smaller one with tiny circles, starting from the outside and working your way into the middle.

2 Add six or seven pointed petals around the centre.

3 Finish with more petals peeking out from behind to give the impression of multiple layers.

More ideas to try

- Add more or fewer petals and try different centres.

- Use longer, thinner petals or shorter, wider ones.

- Try drawing your sunflower from the side, as a bud or on an angle.

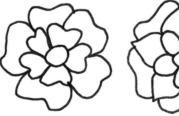 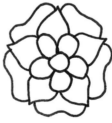 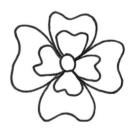

TIP

Adding layers of petals to your flowers will give them depth and make them look more organic. You can use the same petal shapes for your layers or try mixing the shapes so each layer has a different petal shape. You can also draw your petal layers directly over the first petal or start the next layer of petals halfway across your first petal to give a different look.

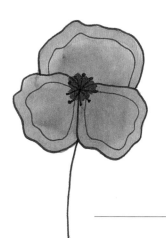

Violet

This early-spring flower symbolizes modesty and is one of the birth flowers for February (see page 140). Violets are in the same family as pansies and violas, and usually have dark purple or white petals with deep-green leaves.

1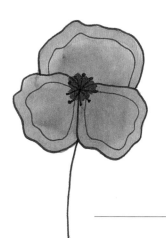

2

3

4

5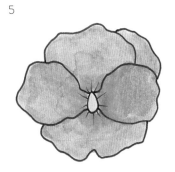

1 Draw a small X shape in pencil as a guide for the first petals.

2 Draw a large, wide semi-circle on each side with a jagged edge to form a sideways figure-of-eight.

3 Add a large, undulating petal across the top.

4 Add another large petal underneath the figure-of-eight, plus a small oval for the centre.

5 Finish with one more petal peeking out at the top on one side and line shading from the centre.

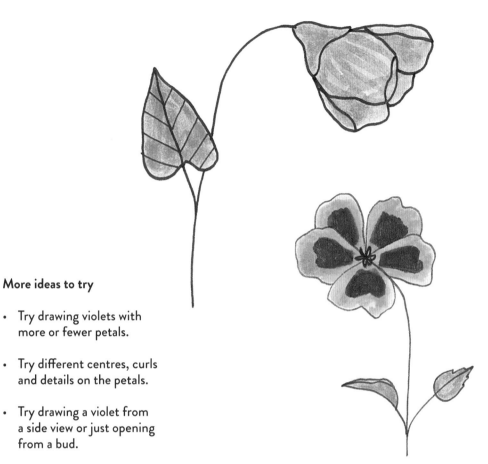

More ideas to try

- Try drawing violets with more or fewer petals.

- Try different centres, curls and details on the petals.

- Try drawing a violet from a side view or just opening from a bud.

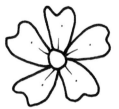 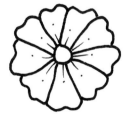

TIP

Drawing petals sitting next to each other versus overlapping petals will change the look of your flower, giving it more depth. To do this, draw one side and the top of the petal, then start the next petal around the first. You don't have to stick with the petals fanning out in a circle; as with an actual violet flower, sometimes the petals overlap more randomly.

Chapter Four

The Projects

An introduction to the projects

If I'm feeling anxious, stressed or bored, or I simply feel like being creative and want to do something nice for myself, these are the projects and ideas I come back to again and again.

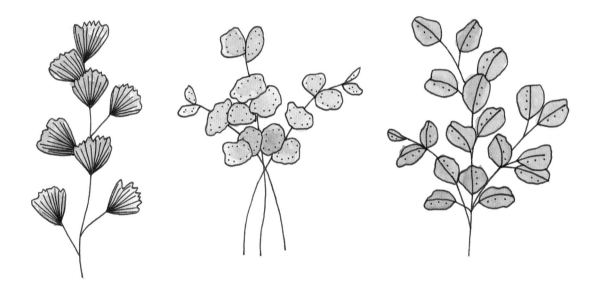

These projects help me to slow down and unwind, and I really enjoy doodling them. They also help me to overcome the blank-page overwhelm when I can't decide what to draw – I hope they will do the same for you.

Before we get started, here are a few tips on composition that may be of help when you come to draw new projects of your own:

- Start by sketching out where the main focus points of the drawing will be with a rough circle, then sketch where you will add the smaller details and leaves.

- Add larger flower heads in odd numbers – ask any florist about this and they'll say to add flowers in groups of three or five. Of course, no one is going to tell you you've done it wrong if your bouquet or drawing has four or six blooms, but generally an odd number will be more aesthetically pleasing.

- When choosing to combine different floral elements, think about which shapes and designs may complement each other and add interest. For example, if I have a big, fluffy bloom with floppy open petals, I might draw a stem next to it with lots of smaller flowers. I also try to repeat leaves, flowers or details a few times within a project to give the finished piece flow and balance.

- Add depth by overlapping blooms at random, and add contrast by turning flowers in different angles, as well as varying the shading and colours.

- Turn your work upside down. I know this sounds odd, but when I can't seem to find the right balance on the page, I find that looking at it upside down gives me a clue as to where extra foliage or another flower is needed.

- Don't forget to check your edges – the overall shape your composition makes on the page and the negative space around it will help to create a more pleasing look. If your edges are too harsh, consider adding more leaves to help soften them.

You'll find many of the flowers and leaves from the earlier chapters among the projects, but you can, of course, vary the selection as much as you wish. And if at any point you are struggling, I have created some free printable templates which you can download via the link on page 137 to make things a little easier. Now take a deep breath, relax those shoulders and get doodling.

Grid of flowers

Breaking the page into a grid makes this a nice easy project to start with as focusing on one square at a time can feel less overwhelming than filling a whole page. You can divide your page into four, six, nine, twelve or seventy-two – it's entirely up to you and as you gain in confidence you can perhaps try more! For this project I used a simple three-by-three grid to create a lovely piece of art fit for any wall.

Time to complete
20 minutes

Flowers used
Daisy (see page 62)

1 Using a pencil and a ruler measure the dimensions of your paper then divide the page into three with little marks across the top and bottom. Connect the marks with lines then repeat the process across the page to divide the page into nine.

2 In the middle of the first box draw a flower such as the daisy on page 62.

3 Work across the boxes adding more flowers – you can either draw different flowers of your choice from Chapter Three, or challenge yourself by doodling one flower, such as the Daisy, in nine different ways. You could consider different angles, varieties or stages of the flower from a bud to starting to open, to in full bloom.

4 Once you are happy with your pencil sketches, go over the flowers in pen then erase all the pencil marks and dividing lines.

5 Add colour or details to finish.

1

2

3

4

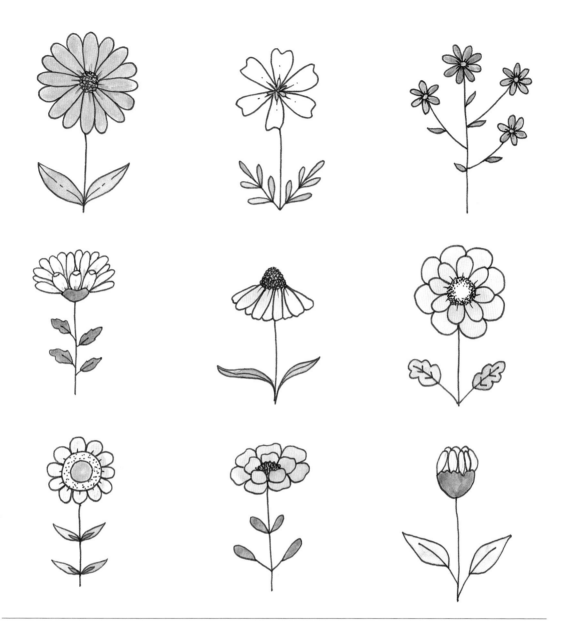

More ideas to try

- Try adding more boxes to your grid and draw a page full of tiny flowers.

- One row of three flowers or leaves will also work, if you want to simplify this idea.

- A grid of 12 birth flowers, one for each month of the year (see pages 140–1), makes a great wall art creation.

(see pages 140–1)

TIP

To save having to measure out and draw the grid lines, check your board games boxes for old cardboard sheets that you have popped the game pieces out of. These are perfect for using as a template to draw round the inside of the empty shapes onto your page.

Simple bouquet

This simple and calming project is perfect for when you have only 10–15 minutes to draw. Try to let go of worrying about making your flowers look realistic and instead allow your intuition to take over. Try mixing up flowers and leaves that appeal to you into one flowing stem or create a super-simplified abstract bouquet. This project works well for the front of a hand-drawn card, as a piece of art for your walls at home, or on a gift tag or bookmark.

Time to complete
15 minutes

Flowers used
Aster (see page 37)
Cosmos (see page 35)
Hydrangea (see page 41)
Peony (see page 54)

1 Start by drawing a vertical, loosely wiggled stem. Draw a couple of wiggly branches either side of the central stem.

2 Sketch out the basic shapes for the flowers at the top of the central stem and at the ends of the branches (see page 29).

3 Add petals and centres to complete the flower heads. You could use a different flower on each branch, or just stick with one or two different varieties – you decide what you think looks best!

4 Add leaves along the stem and branches until you're happy with the look.

5 Go over your pencil marks in pen and erase the pencil. Finish with a few details.

1

2

3

4

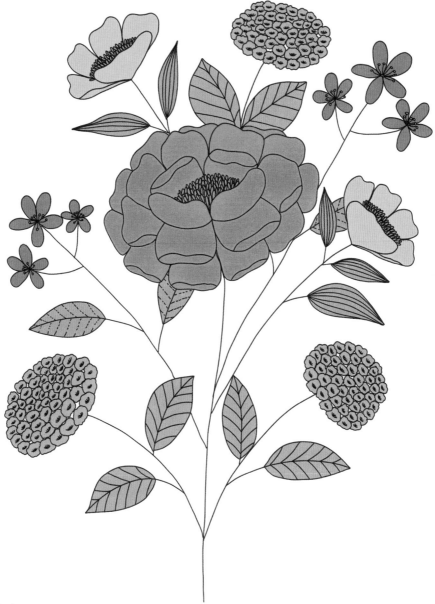

More ideas to try

- Use this technique just with leaves to create different fern-like leaf stems.

- Try using all the same flowers and/or leaves, and then make them all different to see which style you prefer.

- Rather than placing the branches opposite each other to make the stem look symmetrical, experiment with random branches and sub-branches.

TIP

The key to making these stems look natural is to balance the design without making it too perfect and symmetrical.

Overlapping leaves

This meditative doodling exercise is based on one simple leaf shape and lots of repetitive lines, so it's ideal for when you need to slow down and calm a busy mind. As you are drawing the leaves try to tune into how you are feeling today. Are you anxious, stressed, relaxed, content or tired? Where is your mind wandering to as you move across the page? Try to show yourself kindness and acceptance rather than fight against these thoughts.

Time to complete
45 minutes

Leaves used
Leaf shape B (see page 16)

1

2

3

1 Choose one simple leaf shape from Chapter One then sketch out a row of large leaves in pencil along the bottom of the page, changing the angle of each one slightly as you move from one side to the other.

2 Add a second layer of leaves coming from behind this row then repeat as many times as you wish.

3 Go over your pencil lines in pen and erase your pencil marks to give you the outlines of the leaves.

4 Add some vein lines to each leaf, alternating between three or four different styles (see page 22 for ideas) for variety and to help keep your mind focused on the task.

More ideas to try

- Try using this technique with leaf branches, jumbling up the branches in different directions and overlapping them randomly.

- Play with using a mix of different leaf shapes.

- Try adding a light wash of colour to the leaves before or after you add your veining lines.

TIP

The ability to keep your lines straight and equally distanced will improve with practice so don't beat yourself up if they are a little shaky to start with. You might find it easier to draw the lines on one side of the leaf first, so that your marks all go in the same direction and you can concentrate on one movement, before swapping to the other side.

Rainbow

This is a great project to do with children as it's an easy, feel-good way to create a piece of art for their bedroom. Floral rainbows are also lovely to add to cards (maybe a thank-you card for a teacher) or to paint onto a fabric birthday banner or garland.

Time to complete
30 minutes

Flowers used
Aster (see page 37)
Carnation (see page 35)
Cosmos (see page 35)
Lavender (see page 33)
Lily (see page 43)
Tulip (see page 39)

1

2

3

1 In pencil create a rainbow by drawing three progressively larger semi-circles from the bottom centre of the page (or from a horizontal line drawn in pencil higher up the page). You can do this by hand or by using a compass, but try to leave at least a couple of centimetres (roughly an inch) between each one so you have room to add the flowers.

2 Starting from one side of the first semi-circle, draw stems and leaf branches along the top of the arc until you reach the other side. Repeat this on the other semi-circles.

3 Add details and colour to the leaves and flowers to complete your floral rainbow.

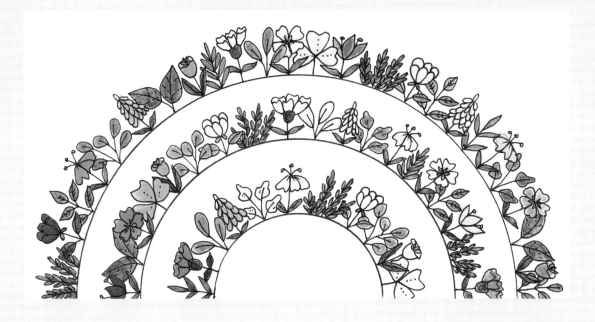

TIP

You can create a sequence of six or seven flowers and leaves then repeat this as you move across and up the rainbow, or challenge yourself to keep adding new flowers as you go along.

More ideas to try

- Add more layers to your rainbow, perhaps by drawing a semi-circle for each colour of the rainbow.

- Start by painting the colours of the rainbow, then draw clusters of flowers at the bottom of each side to represent clouds.

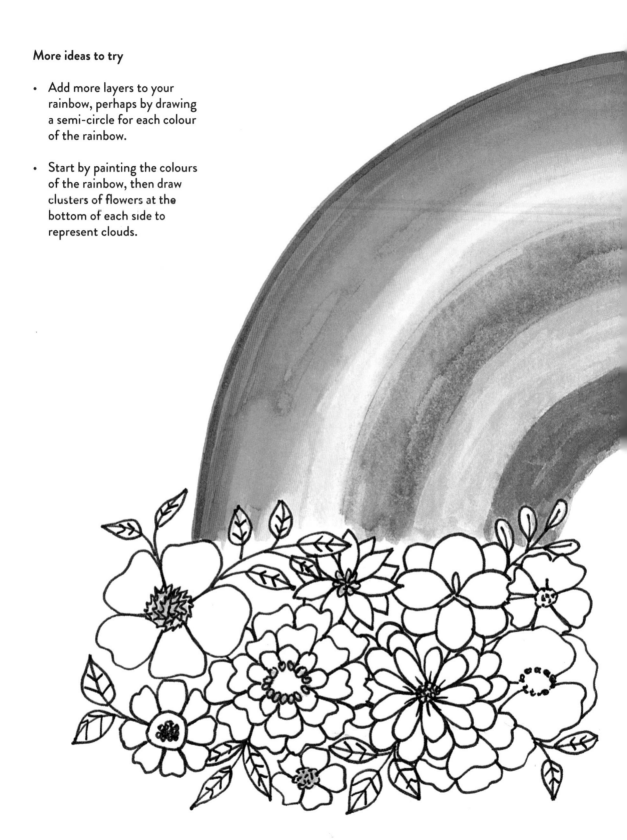

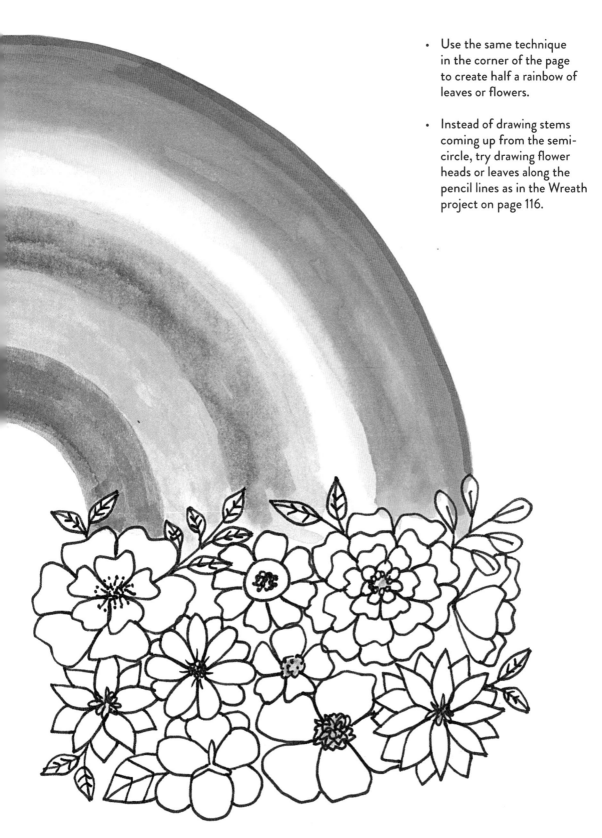

- Use the same technique in the corner of the page to create half a rainbow of leaves or flowers.

- Instead of drawing stems coming up from the semi-circle, try drawing flower heads or leaves along the pencil lines as in the Wreath project on page 116.

Strings of flowers

This project involves a few minutes of pencil sketching to set up guidelines to follow, but it's worth the effort as once you start drawing the flowers you can switch off and enjoy the doodling. It's a good one for drawing on envelopes or brown paper to use as gift wrap and would make a lovely wallpaper design. You can use any flower you like for this but I chose sunflowers as I take my children to pick them at a local farm every summer, making this a wonderfully personal project for me.

Time to complete
30 minutes

Flowers used
Sunflower (see page 64)

1

2

3

1 In pencil draw four or five wiggling lines from the top to the bottom of the page, with equal distances between them.

2 On the first string, add circles in pencil where each flower will be placed, leaving around 5cm (2in) between. On the next string along, place the circles where there are gaps on the previous string. Repeat until you have the guidelines sketched out on each string.

3 In each circle draw a flower head, and draw leaves underneath to create a repeating pattern.

4 Go over the flower heads, strings and leaves in pen then erase your pencil marks before finishing with shading and/or colour.

TIP

Drawing around a small circular object, such a coin, to create your guide, will keep all of your flowers heads the same size. Of course, freehanding as I've done is also totally fine!

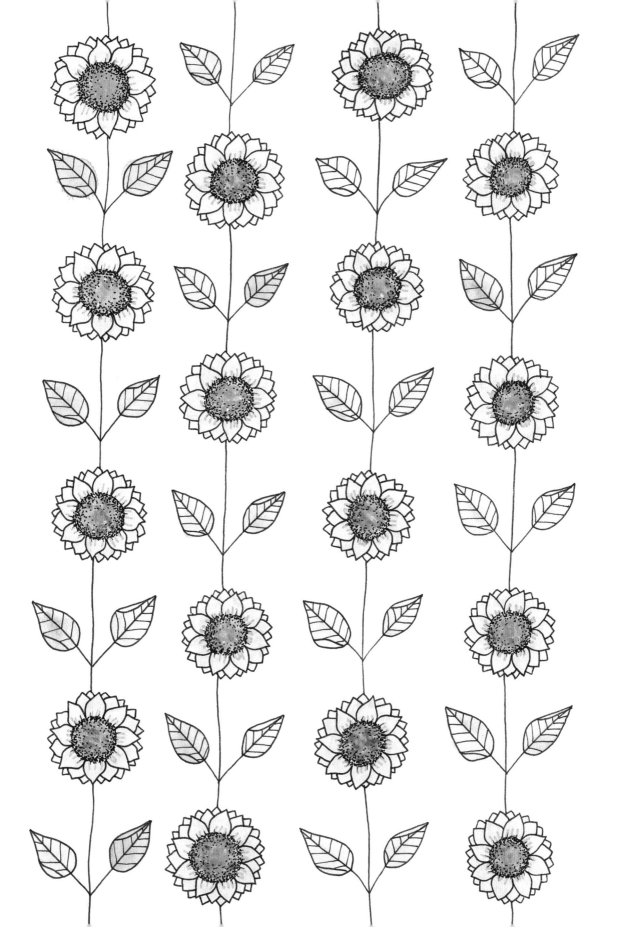

More ideas to try

- Try this technique using large leaves or a mixture of different flowers.

- Try drawing the strings horizontally across the page instead of vertically.

- Use the same technique to create patterns of leaves or flowers (as shown here), and erase the guide 'strings' afterwards for a different look.

Envelope

There's something lovely and nostalgic about receiving post (nice post, obviously – not the bills!). By decorating your envelopes with a quick flower doodle you can spread unexpected joy via good, old-fashioned mail. There are so many different options to add a personal touch to your envelopes but for this project I've gone for a corner design on the front and a secret garden sketch on the inside of the envelope flap.

The corner design I've used on the front also looks very effective on a journal or planner page, or to frame photos in an album. You can use floral corners like this on a full page or within smaller boxes or frames.

Time to complete
20 minutes

Flowers used
Cosmos (see page 34)
Lavender (see page 32)
Lily (see page 42)
Rose (see page 60)

2

3

4 & 5

1 Write the recipient's address on the envelope so you can see where you design needs to finish so as not to obscure the text.

2 In pencil begin sketching out (using rough circles or bowls) where you'd like the main flowers to be in one of the bottom corners. I tend to start with one large flower head then fill in smaller ones on each side.

3 Sketch in the flower petals and try to vary their shape, sizes and density to give a good variety and add interest to the finished floral corner.

4 Add in simple branches of leaves to fill out the spaces between and around the flower heads and build up your corner – you're aiming for the corner to look balanced with the width and height of each side being roughly equal.

5 Go over your flowers and leaves in pen and erase your pencil marks before adding in any details such as flower centres, leaf veining or colour.

6 For an extra touch, open the envelope flap and draw your secret garden inside, coming up from the edges of the bottom half of the envelope (see opposite).

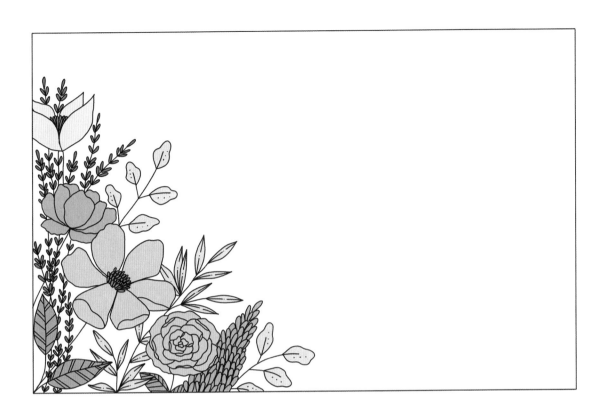

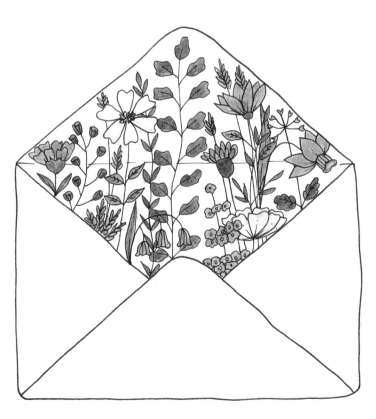

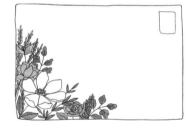

TIP

A sprig or branch of leaves gives a nice, soft finish to the corners on either side of an envelope, completing the shape and making the edges less blunt.

More ideas to try

- Draw floral corners on opposite sides of the envelope. Just remember to leave a space for a stamp!

- If you really want to take your envelopes up a notch, you can also experiment with making envelope liners to give their insides a coloured background to doodle on.

Botanical border

A side border is a good way to doodle lots of blooming flowers together, without the need to fill the entire page. This project is perfect for adding to a page in a journal, on a bookmark or for decorating the top of a weekly planner or schedule.

Time to complete
20 minutes

Flowers used
Anemone (see page 52)
Aster (see page 36)
Cosmos (see page 34)
Peony (see page 54)
Violet (see page 66)

1

2

3

1 In pencil draw a light, vertical line roughly 5–6cm (2–2½in) in from the edge of the page (whichever side you wish) to act as a guide and keep everything even. You don't need to draw right up to this line with each flower and you can go beyond it occasionally, but it's a good marker to help prevent one end of the page ending up much wider than the other.

2 From the bottom corner sketch in your first flower and a few leaves then stack another flower on top (you can overlap them slightly if you feel confident doing so) and continue up the edge of the page until you reach the top corner, adding a different flower each time.

3 Fill in any gaps in between the flowers and soften the edges with leaves, buds or berries.

4 Once you are happy with the design, go over it in pen and erase your pencil marks before adding details or colour.

More ideas to try

- Add borders to both sides of the page if you wish, or rather than drawing up the sides draw along the top and bottom instead.

- Try this technique using large leaves such as ferns, monstera or holly (see page 19).

- Use a metallic gold pen inside of a black ink pen to outline the flowers (I recommend colouring the flowers and leaves first then finishing with the outline).

TIP

Try adding flowers from different perspectives (see page 49) or at different stages of opening (see page 50) to add more interest.

Cascades

A cascade is simply a collection of vines, leaves and flowers that tumble from the top of the page. I've drawn a lot of these as they are super relaxing, especially if you're feeling overwhelmed by the blank page and want something pretty and calming to doodle. You can use cascades to decorate the tops of pages in your journal, on cards or along the top of your notepad to make that to-do list slightly more appealing.

Time to complete
20 minutes

Flowers used
Cosmos (see page 34) Fuchsia (see page 38)
Hydrangea (see page 40)

1 From the top of the page draw a curving line vertically to roughly a third to halfway down the page. Add leaves, either coming directly from the stem or from extra branches, until you've filled the vine up, then add a small leaf to the end.

2 Repeat, this time adding flowers and a few small leaves. Try to mix up the size and density of the flowers and leaves; for example if you chose large leaves for your first vine, I would recommend using smaller, more delicate flowers for this one, and vice versa.

3 Carry on adding more vines across the page, overlapping them every now and then or leaving the odd gap to make your drawing look natural. I also try to vary the lengths of the vines across the page to give the bottom a nice shape, moving the focus gently up and down along it.

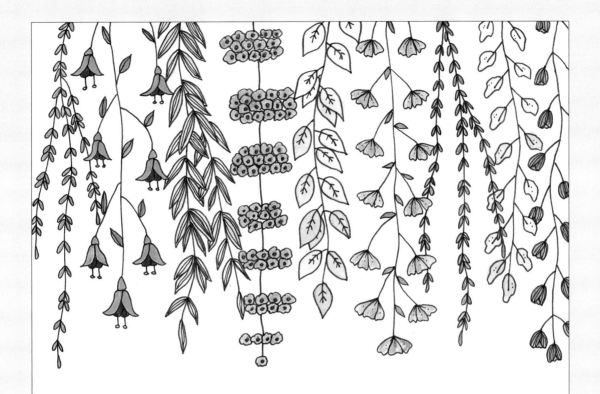

4 If you have any areas of the page that look a little too empty, you can split one of your vines by adding additional branches to fill out the space. Once you're happy, go over your sketch in pen then erase the pencil marks before adding any details or colour you like.

TIP

Don't be afraid to repeat leaf shapes or vines that you've already used on the page on the other side; repeating them adds a nice consistency.

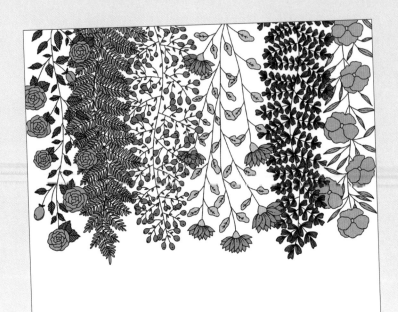

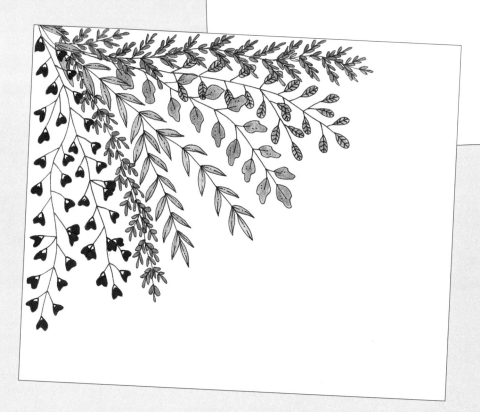

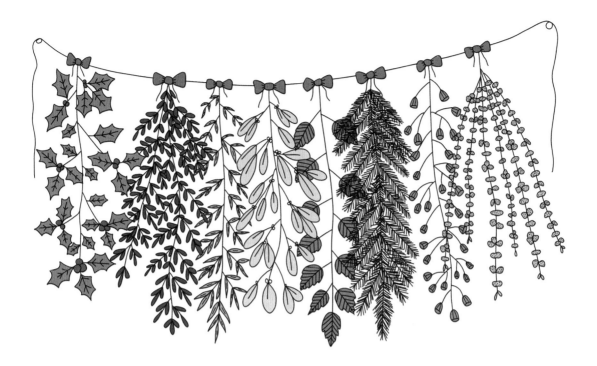

More ideas to try

- Use the cascade technique just in once corner rather than across the full width of the page.

- Try using a mixture of different flowers and leaves, or just leaves.

- Have fun playing with the spacing and lengths of your vines.

- Experiment with different seasonal cascades. This festive example includes a decorative string holding the hanging sprigs, rather than using the top of the page.

Floral animal

This is a fun way to create gorgeous artwork for your walls, a card for a loved one or colouring sheets for the kids using their favourite animal. I've drawn lots of different animals including our dog, several different dinosaurs for our dino-loving son and, of course, the odd bunny rabbit at Easter. I've chosen a turtle here, but you can use any animal you like – a butterfly would also be a lovely one to start with.

Time to complete
45 minutes

Flowers used
Aster (see page 36)
Cosmos (see page 34)
Water lily (see page 42)
Sunflower (see page 64)

1 Sketch out your chosen animal silhouette outline in pencil – you can find an animal shape online and trace it onto your page (or trace the turtle outline), but make sure the silhouette is easily recognizable without all the inner details.

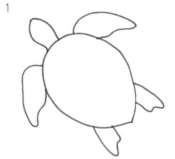

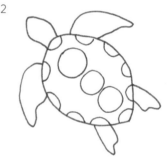

2 Within this outline, break the shape into sections where it makes sense to do so (for example, the turtle's shell, head and flippers make good sections). If you have a particularly large area, such as the main body or the turtle shell here, divide up this area with circles or semi-circles where you will place flowers.

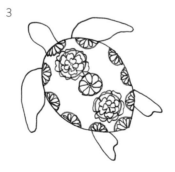

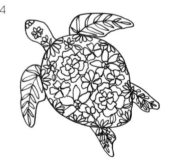

3 Draw the flowers into the spaces you've marked in the largest section, adding leaves and smaller flowers to fill the space well.

4 Add leaves or flowers to the legs/flippers, head and other smaller areas to complement but not compete with the large area you've already completed.

5 Go over your outline, leaves and flowers in pen and erase your pencil marks before adding any final details, shading or colour.

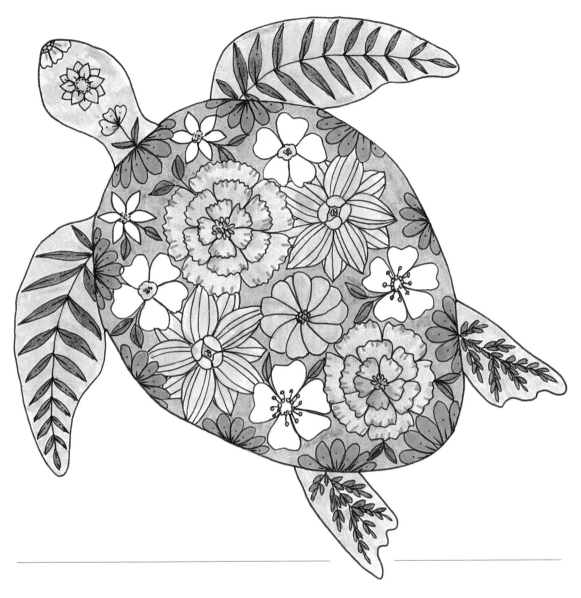

More ideas to try

- As well as trying different animals, you could also use this technique for other shapes such as buildings, seashells and handprints or footprints.

- If you want a challenge, you could also trace the outlines of people from a family photograph and create a personalized floral family portrait.

- Play around with adding colour to your animal or to the background for different looks.

Peaceful patterns

If I could draw only one project from this book, it would be this one. Although it seems simple, I've doodled more pattern pages than anything else throughout my sketchbooks and no two are ever the same so I never tire of them. It's like playing Tetris with flowers, and the challenge of distributing them evenly throughout the page keeps my brain engaged but relaxed. I hope you enjoy drawing them as much as I do.

Time to complete
45 minutes

Flowers used
Aster (see page 36)
Bell heather (see page 30)
Cosmos (see page 34)
Larkspur (see page 32)
Lily (see page 42)

1

2

3

1 Starting in the top corner of your page sketch out seven or eight different flowers and leaves, aiming for good variety among them. I always try to include a branch of leaves that can be easily expanded to fill in gaps that aren't quite big enough to squeeze in another flower.

2 Repeat step 1 to fill up the page, sketching in the flowers and leaves at different angles and orders as you move across and down your page. Try not to place two repeating elements next to each other, and keep checking that you're using each flower or leaf and not forgetting about one.

3 Once you've filled up your page, check that you've got each flower and leaf in each quarter of the page and there are no obvious gaps.

4 Go over your pencil sketches in pen then erase the pencil marks before adding details to your flowers and leaves.

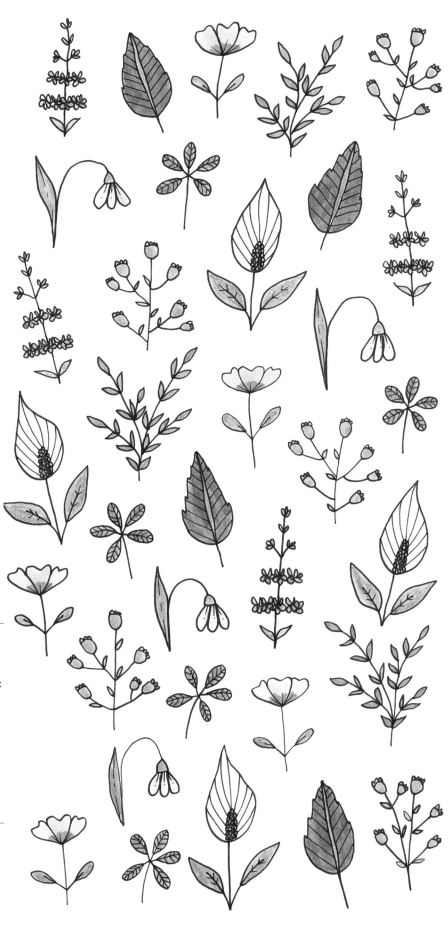

More ideas to try

- You can create a very satisfying pattern page using just leaves or even just one leaf shape.

- Try drawing patterns with seasonal elements such as pumpkins or seasonal flowers.

- Experiment with adding other doodle elements into the negative space, such as stars, diamonds, dots or dashes, to add a little sprinkle of extra magic.

TIP

Remember to keep your spacing and sizing consistent all the way down the page. I have to be quite mindful of the sizing in particular as I often find my flowers become larger as I move towards the bottom of the page!

Flower arrangement

Drawing your own flower arrangement is the ultimate creative escape. This design is based on looking down on a bouquet; however, we're going to play around with the shape. Hand-drawn flower arrangements are perfect for colouring pages, gift tags or greetings cards.

Time to complete
30 minutes

Flowers used
Anemone (see page 52)
Cosmos (see page 34)
Lily (see page 42)
Peony (see page 54)
Violet (see page 66)

1 2 3

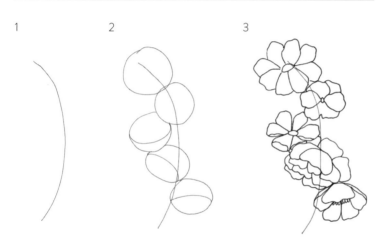

4

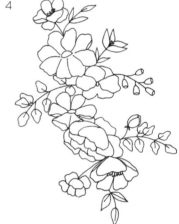

1 Sketch out a large arc down the centre of the page in pencil to act as a rough guide (don't worry if you don't end up sticking to this, but it's useful to have as a guide).

2 Place five circles along this guideline to mark where the main floral focal points will be. Try to vary the sizes and their position a little (for example to either side of or across the middle of the arc).

Consider varying the direction your flowers are facing, using simple bowl shapes to help plan this.

3 Begin to draw in your flowers trying to vary the petal shapes and centres.

4 Add smaller flowers, buds, berries and sprigs of leaves to fill out the arrangement.

5 Finish by adding leaves until the composition looks balanced and natural.

6 Draw over your pencil marks with pen before erasing and finishing with your chosen details or colours.

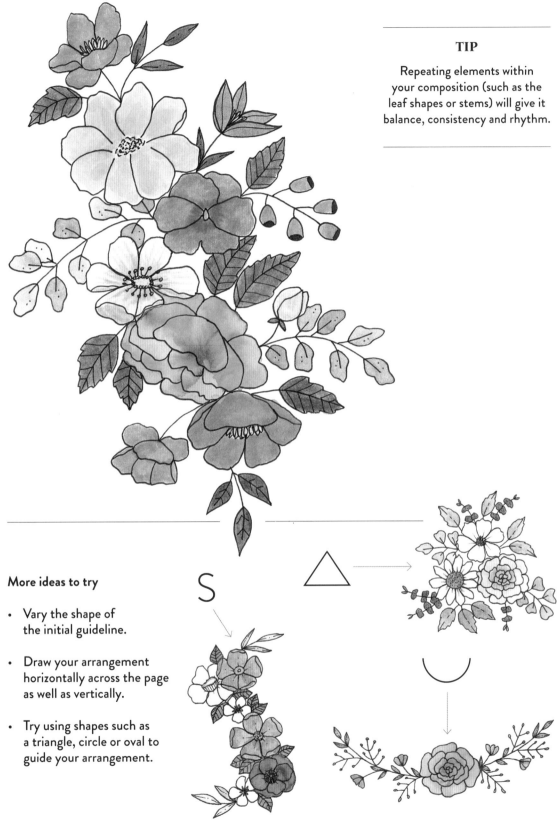

More ideas to try

- Vary the shape of the initial guideline.

- Draw your arrangement horizontally across the page as well as vertically.

- Try using shapes such as a triangle, circle or oval to guide your arrangement.

Full floral border

This project looks intricate when complete, but it's a pretty straightforward way to draw flowers. It's ideal for doodling around a weekly schedule or meal plan or to surround a title page in your journal. It would also make a gorgeous design for wedding stationery or a garden party invitation.

Time to complete
60 minutes

Flowers used
Aster (see page 36)
Baby's breath (see page 44)
Daisy (see page 62)
Lavender (see page 32)
Lily (see page 42)
Lily of the valley (see page 38)

1

2

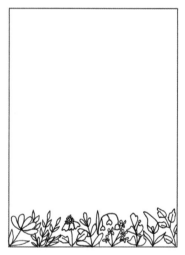

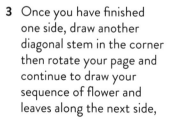

3

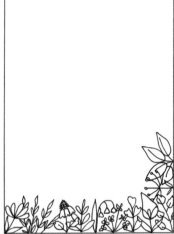

1 In one corner of the page draw your first flower or leaf stem coming out into the page diagonally – the makes the transition of the border into either side of the page smoother.

2 From this first flower (or leaf) continue to doodle flower and leaf stems. The easiest way is to create a simple combination or sequence that you can repeat as you move around the page. I try to use the leaves to overlap slightly between the flowers so that it fills up empty space.

3 Once you have finished one side, draw another diagonal stem in the corner then rotate your page and continue to draw your sequence of flower and leaves along the next side, repeating until all sides of your page are full. Check whether there are any areas where the border looks thinner or might need some extra height; extending your leaf branches is a good way of balancing this out.

4 If you've worked in pencil, you can now go over in pen and finish your leaves with a few simple veining details.

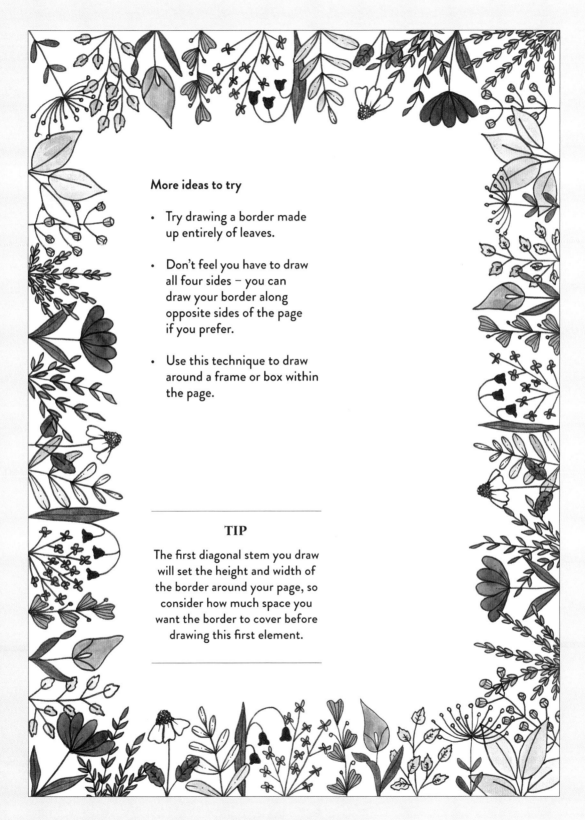

More ideas to try

- Try drawing a border made up entirely of leaves.

- Don't feel you have to draw all four sides – you can draw your border along opposite sides of the page if you prefer.

- Use this technique to draw around a frame or box within the page.

TIP

The first diagonal stem you draw will set the height and width of the border around your page, so consider how much space you want the border to cover before drawing this first element.

Secret letters

If you're feeling tense or stressed, giving your brain something logical to work through can help to slow down and calm your mind. This project is ideal for this as it involves challenging yourself to create flowers from letters of the alphabet, which is also good for exercising your creativity! Children love this project as they can use it to create secret messages.

Time to complete
20 minutes

Flowers used
Baby's breath (see page 44)
Cosmos (see page 34)
Lily (see page 42)
Peony (see page 54)
Tulip (see page 38)
Water lily (see page 42)

a

w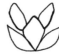

q

1 Write your chosen letter in pencil. It will need to be large enough, and with plenty of space around it, so you can transform it into a flower

2 Try to identify how you could turn your letter into a flower by completing loops to form the centre of a petal, extending straighter lines into stems or maybe forming the centre lines of petals.

I've chosen a few letters here to demonstrate some examples, but you can draw the whole alphabet – once you get going, you'll see more possibilities! If you are struggling, you could also go back over the flowers in Chapters Two and Three and see whether you can draw letters into any of the shapes.

3 Once you've created your flower, go over your pencil marks in pen and erase the pencil marks.

a

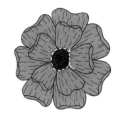

k

x

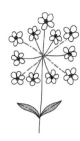

u

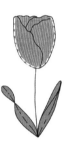

e

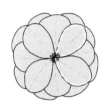

y

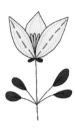

w

q

o

TIP

You can leave the letter you've used for the flowers a secret or trace over the letter in a coloured pen.

More ideas to try

- Try this technique with numbers – maybe for an important date to frame for the wall.

- Try it with capital and lower-case letters to see which you prefer. I find lower-case letters are easier as they are more loopy.

- Use secret floral letters to spell out the name or initials of a new baby to make a lovely, personal card or gift for their nursery wall.

Miniature garden

Attempting to draw an outdoor space such as a garden can feel overwhelming, as there is so much detail to take in. However, if you narrow your viewpoint and draw the garden within a shape (such as a circle), it becomes much more achievable. Simplifying the design will help you focus on the present moment and pay close attention to the most interesting elements in front of you.

This project is a great one to do out in the garden or a park. It will help you notice what's growing throughout the year, and each circle can be a little window into a particular time and place.

Time to complete
30 minutes

Flowers used
Aster (see page 36)
Cosmos (see page 34)
Daffodil (see page 58)
Hyacinth (see page 40)
Lily (see page 42)
Poppy (see page 30)
Tulip (see page 38)

1 Draw a circle in the centre of the page by drawing around a circle maker or bowl, or by using a compass. I recommend drawing the circle in pen as it's very tricky to then line up the circle exactly to go over the pencil marks.

2 Switch back to pencil to sketch in the flowers. Start in the base of the circle and add a variety of flower stems and leaves as you move up either side of the circle.

3 Once you have sketched around halfway up the circle on either side, start to bring the flower stems or branches in, drooping over and inwards towards the centre.

4 To fill up the rest of the space, add some branches and flower stems at the top of the circle, hanging down towards the centre as if they are vines.

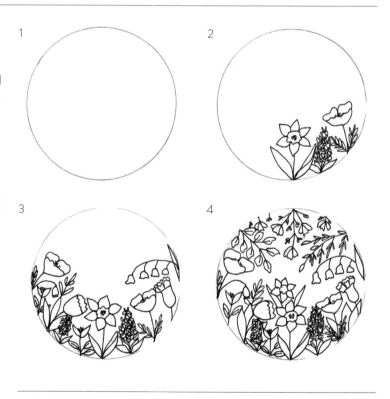

TIP

Leaving a little bit of negative space in the centre of the circle and not filling it up too tightly will give your design some breathing space and a feeling of airiness, as if you are peering through the branches.

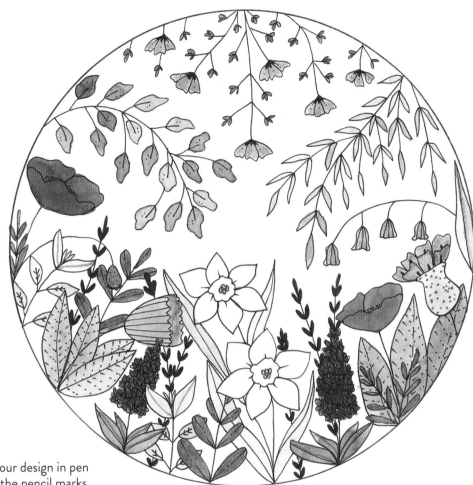

5 Go over your design in pen and erase the pencil marks then finish with some smaller details and colour.

More ideas to try

- Instead of filling in the top half of your circle, for a softer look, create a curved semi-circle in the lower half with large flowers in the middle and small leaves and flowers finishing each side.

- Experiment with filling up the circle in different ways, perhaps with stems, branches or vines coming into the centre from all the way around the circle.

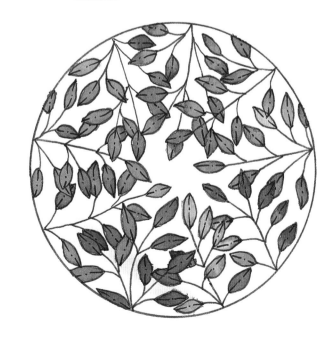

Zen blossoms

Zen doodling is a meditative style of drawing where you create small areas of simple patterns to build up a bigger, usually more intricate picture. It tends to be more abstract so it's a good exercise to release any inner judgement and criticism around your flowers and just draw!

Time to complete
90 minutes

Flowers used
Cosmos (see page 34)

1 Anywhere on your page, start by drawing a large, simple flower with heart-shaped petals, then build up your flower with two or three more layers of petals.

2 Repeat the same flower outline at random places all over your page until you run out of space. It will look more interesting if you overlap the flowers occasionally and vary their sizes and number of layers.

3 Once you've filled up your page with blooms, fill any gaps with a few simple leaves.

4 Trace over your flower outlines in pen and erase your pencil marks.

1

2
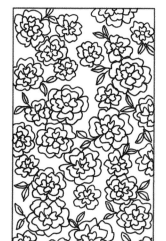

3

4
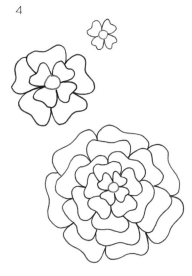

5

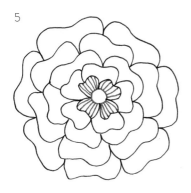

5 Now you can start the relaxing bit of adding coloured pen lines to your petals! Start from the centre and add smooth lines up to the edge of the petals, moving with the shape as you go along the petal. Try to keep all the lines equally spaced.

6 Finish by adding detail to the flower centres (or you can leave them white if you like) and erase your pencil lines.

More ideas to try

- This project looks just as effective in black and white as it does with colour.

- Play with adding other patterns instead of lines (circles, for example) to your petals.

- Colour in the background or negative space surrounding your flowers if you wish.

- If you haven't got much time (or patience!), try this project on a smaller piece of paper.

TIP

As you draw your flowers, keep rotating your paper and taking an occasional step back to check the design is looking balanced and well spaced so you don't end up with a large, tight cluster of flowers in one corner.

Leaf chain

These leaf chains look really impressive but they are simple to achieve, and I hope you'll find the process as satisfying and relaxing as I do. For me, one of the unexpected benefits of drawing is that I pay attention to and appreciate little things that I'm not sure I noticed before. As I go about my daily life, I'm always on the lookout for new leaf shapes on walks, interesting flowers in people's gardens or nature-inspired patterns on fabrics or wallpaper to utilize in projects like this one.

Time to complete
35 minutes

Leaves used
Leaf shape G (see page 18)

1 Draw a squiggly line from one corner of your page diagonally to another. Starting from the bottom, add branches with three to five stems coming off each.

2 Add any leaf shape you'd like to the end of all the branches. In my example, I've used a very loose, wiggly heart-shaped leaf.

3 Continue up the central curve adding branches and leaves on each side of the line until you reach the top. You may need to overlap some of the leaves as you go.

4 Trace over your pencil lines in pen, leaving out any where the central line has been overlapped by a leaf, then erase your pencil marks.

5 Add simple, thin lines to your leaves and finish by adding a thicker tip to each one in coloured pen.

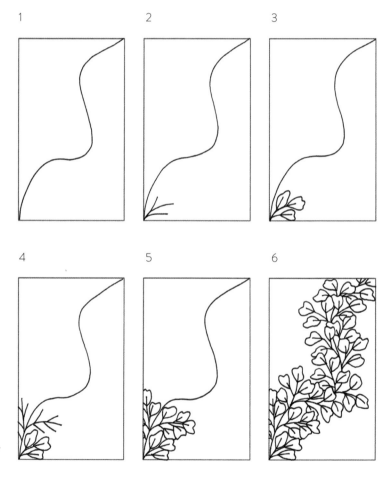

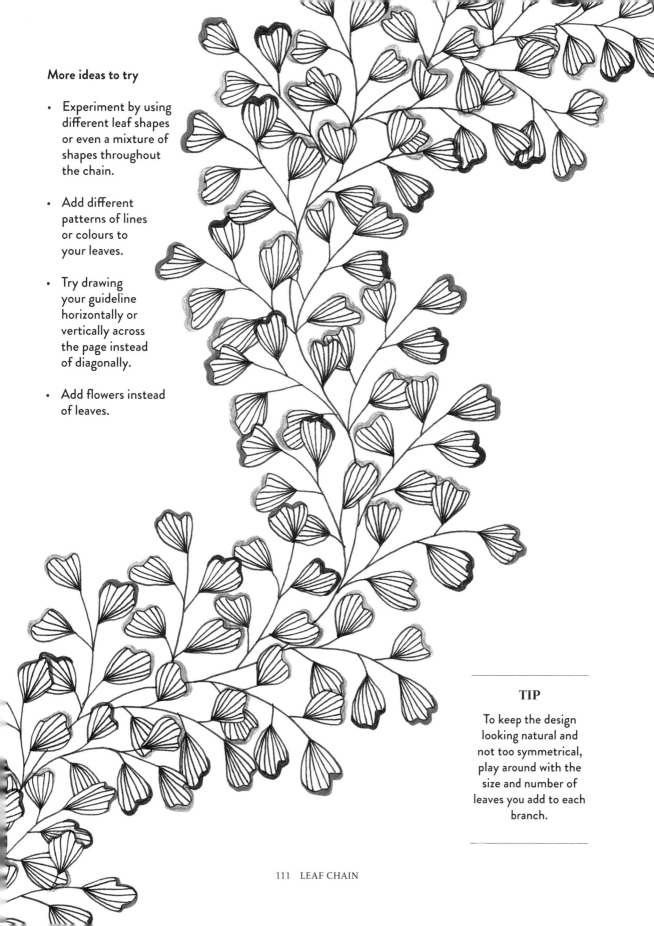

More ideas to try

- Experiment by using different leaf shapes or even a mixture of shapes throughout the chain.

- Add different patterns of lines or colours to your leaves.

- Try drawing your guideline horizontally or vertically across the page instead of diagonally.

- Add flowers instead of leaves.

TIP

To keep the design looking natural and not too symmetrical, play around with the size and number of leaves you add to each branch.

Flower moon

Drawing flowers around shapes such as a crescent moon, a house or an animal silhouette can make lovely designs for stationery or artwork for your walls. They're particularly good for seasonal cards. I've added florals around pumpkins, Easter eggs, Christmas trees, and so on. You name it, it's been drawn around!

Time to complete
30 minutes

Flowers used
Anemone (see page 52)
Cosmos (see page 34)
Lily (see page 42)
Poppy (see page 30)
Rose (see page 60)

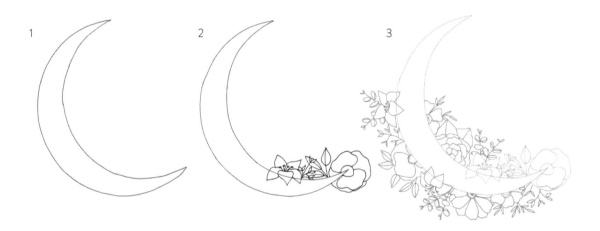

1 Sketch a crescent moon shape in pencil in the centre of your page – you can draw it freehand or download the template (see page 137 for the link).

2 Decide on four or five flowers you'd like to use, and sketch them all around the edge of the shape. You're aiming for the inside of the shape to be mostly empty. However, if it's easier, you can draw the whole flower crossing over the outline shape then rub out the pencil marks that are inside the shape after you've gone over the flowers that are outside of the outline in pen.

3 Add branches or sprigs of leaves between the flowers and coming from behind to soften the edges and fill out the surrounding design.

4 Go over your pencil design in pen (just up to the shape outline) before erasing the pencil marks.

5 Finish by adding some shading, extra details or colour.

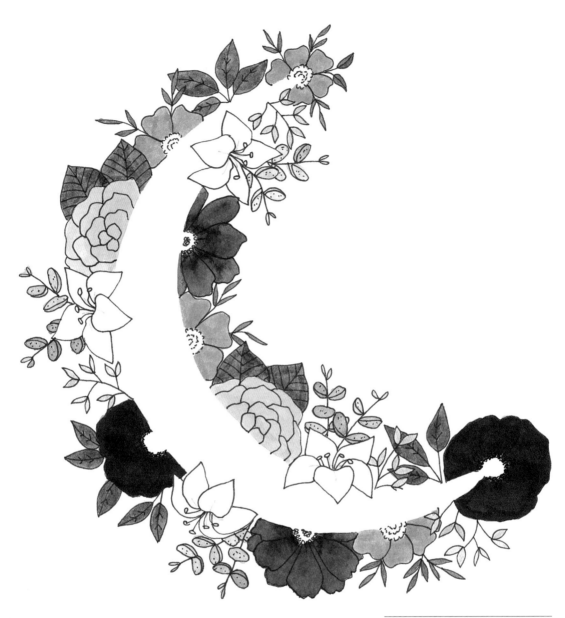

More ideas to try

- Instead of drawing your flowers on the outside of a shape, you can swap it around and just draw on the inside.

- If you prefer to keep the outline of the shape in your drawing, go over your sketch in pen after step 1.

- Add a title or your favourite quote to this design by drawing two lines across the initial shape in pencil, then writing in between them and erasing all of the pencil marks afterwards.

TIP

Use a smaller nib (such as 0.1mm) when drawing finer, more delicate florals. If you wish, you can choose to emphasize one flower by drawing in their petals inside the moon's outline as I've done here with the lilies.

Wildflower meadow

I love sketching these imaginary meadows full of wildflowers, leaves and brightly coloured stems. They're great for drawing on gift tags, cards, doodling on a journal page or along the bottom of photo album pages. I also used this on the inside of the envelope project on page 86.

Time to complete
20 minutes

Flowers used
Aster (see page 36)
Cosmos (see page 34)
Poppy (see page 30)
Tulip (see page 38)

1

2

4

1 In the bottom corner of your page, sketch in a flower stem of your choice from Chapter Three. I like to draw two or three of the same flower at various angles to give the meadow a natural feel and set its rough height to follow across the page.

2 Draw a variety of flower stems and leaves peeking out from behind and overlapping each other as you move along the bottom of the page.

Adding lots of foliage helps to fill any gaps beneath the flower heads and keeps the look natural and organic.

3 Don't be afraid to repeat flowers and leaves as you go to give your meadow good rhythm and balance without looking too unnaturally symmetrical or organized.

4 Although you're aiming for the overall piece to maintain roughly the same height

across the page, try to vary the heights of the flowers a little – you can always add more leaf branches to fill any gaps in.

5 Go over your pencil marks in pen, then erase, and enjoy adding more details.

More ideas to try

- Try moving the design up the sides of your page a little by bringing in flower stems from the side.

- For a simpler version, try this design with just one type of flower.

- Leaves and grasses work just as well as flowers here.

TIP

Lots of overlapping leaves and flowers can be tricky. Sketch in pencil first so it's much easier to decide which lines should be in the foreground and which lines won't be seen once you go over them in pen, and erase the marks you don't need anymore.

Wreath

Wreaths are a popular and classic drawing project that are good for so many different things: a page in your journal or planner, stationery, art for the walls and seasonal cards. They look really attractive and it's a satisfying way to draw flowers as even a few simple flowers and leaves look very effective arranged in a wreath. I've gone with winter greenery in this wreath, but you can create different looks for each season depending on the leaves, flowers or other decorations you add to your design, such as ribbons, fruits and vegetables, or candles.

Time to complete
45 minutes

Leaves and flowers used
Bell heather (see page 30)
Leaf shapes A, E, H, I (see pages 16–19)

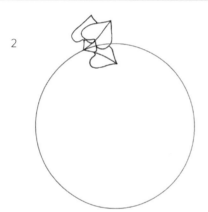

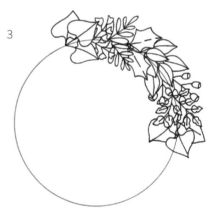

1 Draw a circle in pencil, using a compass or by drawing around a bowl or other circular object, in the centre of the page.

2 Sketch in the first few leaves anywhere around the circle, bringing the stems out above and inside the circle outline at varying angles (you may want the leaves to cross the line too, which is totally fine; this is simply a guide).

3 Continue adding more leaves, berries and flowers to fill up the circle outline as you work around clockwise. I tend to create a sequence that roughly covers a quarter to a third of the circle then repeat this to give the finished wreath repetition and balance.

4 Once you've completed the circle, review your wreath for areas that might need adjusting. For example, a few branches might need lengthening or adding to balance it out, or perhaps a couple of the elements might need to be redrawn slightly smaller to keep the overall circle shape looking even.

5 Go over the final design in pen, then erase the guideline and any sketch marks before adding details and/or colour to finish.

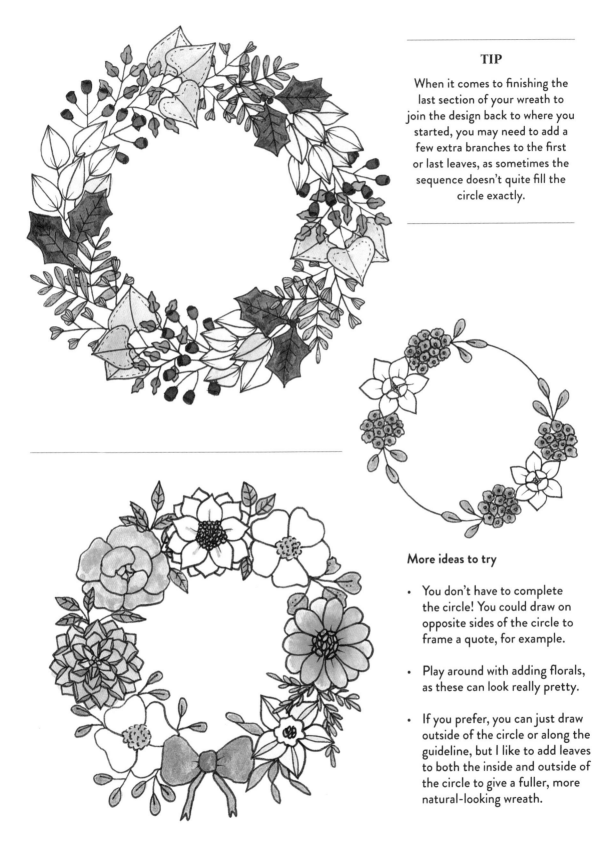

TIP

When it comes to finishing the last section of your wreath to join the design back to where you started, you may need to add a few extra branches to the first or last leaves, as sometimes the sequence doesn't quite fill the circle exactly.

More ideas to try

- You don't have to complete the circle! You could draw on opposite sides of the circle to frame a quote, for example.

- Play around with adding florals, as these can look really pretty.

- If you prefer, you can just draw outside of the circle or along the guideline, but I like to add leaves to both the inside and outside of the circle to give a fuller, more natural-looking wreath.

Birth-flower bouquet

Bouquets are a popular project, as you can make them as simple or elaborate as you like. The key here is to refer back to the basic techniques for the leaves and flowers, using simple shapes to plan out your design before you start. You can choose any of your favourite flowers for your bouquet, but to make it more personal, include the birthday month flowers of your friends or family members. In my example, the birth flowers I'm including are a daisy for April, a rose for June, a poppy for August, an aster for September and a marigold for October. There is more than one birth flower to choose from for each month (see page 140), so go with the ones you think will work best together.

Time to complete
45 minutes

Flowers used
Aster (see page 36)
Daisy (see page 62)
Marigold (see page 56)
Poppy (see page 30)
Rose (see page 60)

1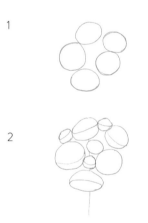

2

3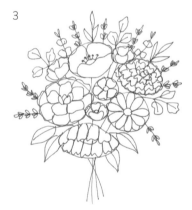

4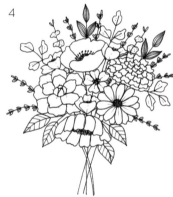

1 In the centre of the page, sketch out where you want the five main flower heads to be using simple pencil shapes and considering what angles your chosen flower heads would naturally face.

2 Add smaller flowers or stems to fill out the bouquet around the main flowers.

3 Start to refine the main flowers by drawing in their petals and centres.

4 Add sprigs of leaves and simple flowers such as lavender to soften the edges and fill out the bouquet.

5 Go over your pencil marks in pen and erase all the pencil marks before finishing with details such as leaf veining, a bow, a vase or colour.

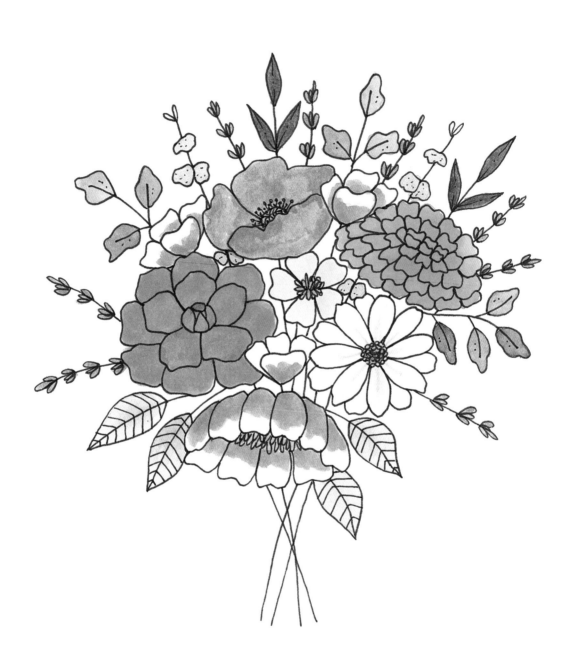

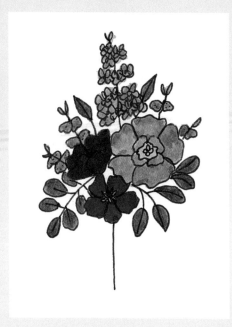

Larkspur, cosmos, eucalyptus

Cosmos, eucalyptus, Queen Anne's lace

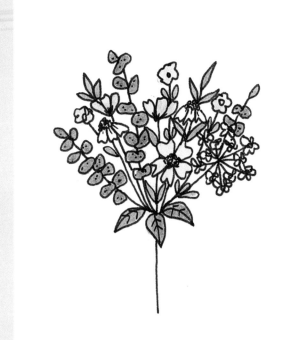

Marigold, cosmos

More ideas to try

- Experiment with adding more or fewer flowers to your bouquet, and mixing up the ratio of leaves and flowers.

- Try drawing mini bouquets in a grid (see page 72).

- Play around with the shape of your bouquet by making them wider or taller.

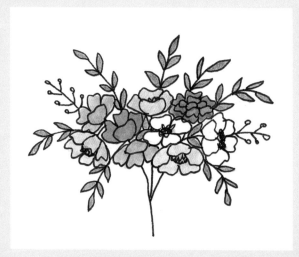

A June bouquet of peach-coloured roses with lovely green leaves to contrast

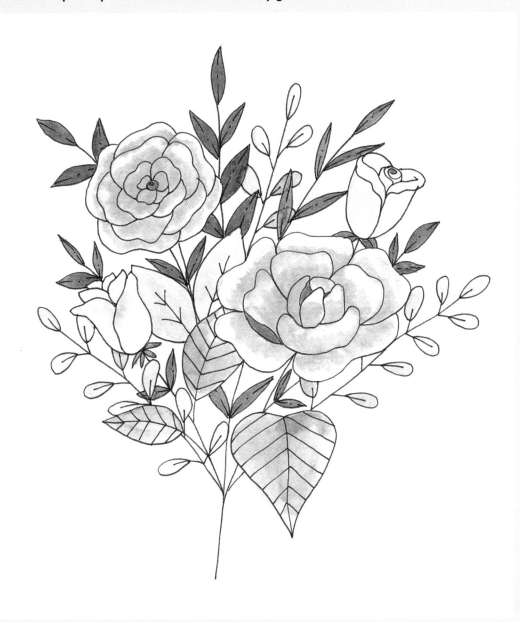

TIP

Sometimes trying to draw every single stem of the bouquet can get a little messy at the bottom, with lines crossing over everywhere. Try not to worry too much about lining up every single flower with a stem; a few lines will do the job.

In full bloom

In this project we're going to fill the whole page with flowers. I've used just about every flower head we've covered in the book, plus a few variations, but you decide which flowers you want to use on your page – and choose the size of your paper wisely! The end result will be a gorgeous design you can frame for your walls, photocopy as a colouring page or print on a T-shirt.

1 In pencil, sketch a large flower into the top corners of your page, so that a quarter of each flower head is showing.

2 Fill in the space between the flowers with one or two more large flower heads, varying the petal styles.

3 Add sprigs of leaves or clusters of smaller flowers to fill any gaps.

4 Continue adding flowers down the page, including lots of variety in their size and shapes. Don't be afraid to repeat your favourite flowers to give your page balance.

TIP

Overlap the blooms randomly (where appropriate) to give your page more depth and to make the design look natural. Drawing partial flowers at the edges of the page (as you did in step 1) will also help give a natural effect.

Time to complete
120 minutes

Flowers used
Anemone (see page 52)
Daffodil (see page 58)
Dahlia (see page 56)
Daisy (see page 62)
Hydrangea (see page 40)
Marigold (see page 56)
Peony (see page 54)
Poppy (see page 30)
Rose (see page 60)
Sunflower (see page 64)

More ideas to try

- Draw a shape in the centre of the page, such as a circle, heart or a loose, wiggly shape to be left blank. If you like, you could add a favourite quote or message here once you're finished.

- Build up a large page over a long period, adding a different flower each time you come to it, to create a gorgeous reference page that can be used as inspiration when you're working on other projects.

1

3

Leaf mandala

A mandala is a circular design of intricate, geometric patterns that are symbolic in a number of cultures and are often used in spiritual meditation and mindful art. Simple mandalas were my very first doodles when I began drawing flowers several years ago, so this project holds a special place in my heart. To make getting started even easier, I've included the grid I used in the printable templates (see page 137), and you can also find grids online to print out or even buy books of different mandala grids. I've used only one leaf shape, but by drawing each layer in a different way, it makes a simple but effective design.

Time to complete
75 minutes

Flowers used
Leaf shape E (see page 17)

1 To draw the guideline grid, use pencil and a compass to draw four concentric circles gradually increasing in size, leaving roughly 2–3cm (about an inch) between each one.

2 Draw a line vertically through the centre and then divide up the circles by marking around the outside of the last circle every 20 degrees until you reach the starting point again. Use a ruler to join the marks through the centre of the circle, splitting your circle into 16 equal parts. This forms the mandala grid and will guide your leaf placement.

3 Starting in the central circle, draw your first leaf shapes. I've drawn eight simple leaves across every other line.

4 In the second circle out from the centre, draw a small branch of leaves over every line around the circle.

5 In the third circle from the centre, draw a three-leafed branch across every other line starting from the first vertical one. I've added a small, decorative circle above each branch, then three circles next to each branch on the lines between them.

6

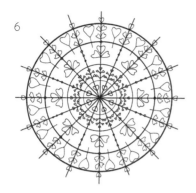

TIP

I like to draw directly onto the gridlines as well as in the gaps either side of them and then mix this up on each layer to add interest and variety.

More ideas to try

- Have a go at using different leaf shapes or adding flowers to your design.

- Try using different numbers of circles and changing the spacing between them, or divide your circle into more or fewer sections to make your mandala more or less intricate.

- Search online for 'mandala art' for lots more inspiration and different patterns to try.

6 In the final circle, draw a branch on each line, with the topmost leaf sitting just outside the last ring. In between each branch, draw a single heart-shaped leaf ending below the outer line, with its stem just crossing into the next circle in.

7 Go over your design in pen and erase all your pencil marks and grid lines. Finish by adding details to your leaf shapes and colour if you wish.

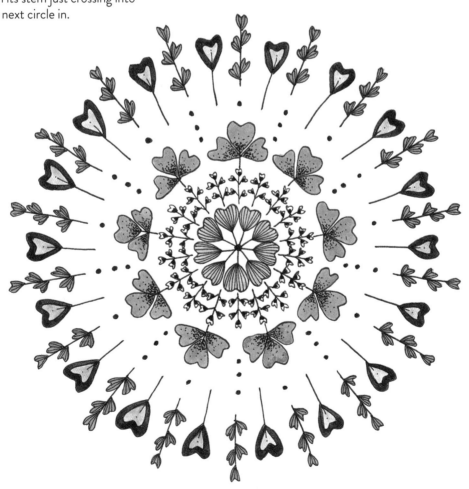

Monogram

These monograms take a similar approach to the Flower Moon on page 112, but I think they're worthy of a separate project as I'm often asked how I draw them. They make a gorgeous design for nursery art, a thoughtful card for a loved one or when you begin a new month in your journal.

Time to complete
75 minutes

Flowers used
Bell heather (see page 30)
Cosmos (see page 34)
Daisy (see page 62)
Lily (see page 42)

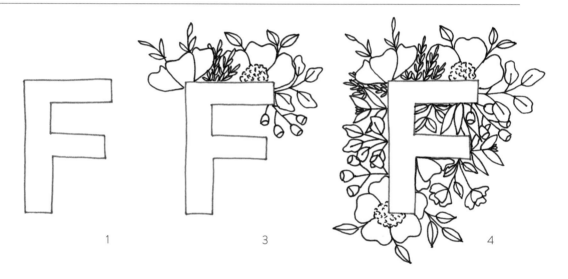

1 3 4

1 Open a word processor on your computer, type your letter in and print this out (I used Arial font at size 600). Trace your letter outline in pencil onto the centre of your paper, or copy it freehand.

2 Choose four or five flowers and some leaves and begin to add them in a sequence you can repeat. Try not to cross the letter outline – although don't worry if you do, as you can erase the marks later. Mix up your flowers and leaves using small, intricate branches next to large, loose petals, and so on.

3 Continue all the way around your letter, repeating sequences of stems and using plenty of leaves to fill in any gaps and soften the outer edges.

4 Go over the flowers and leaves up to the outline (but not inside it) in pen then erase the pencil marks and the lines of the original letter.

5 Add details and/or colour to your flowers and leaves to finish.

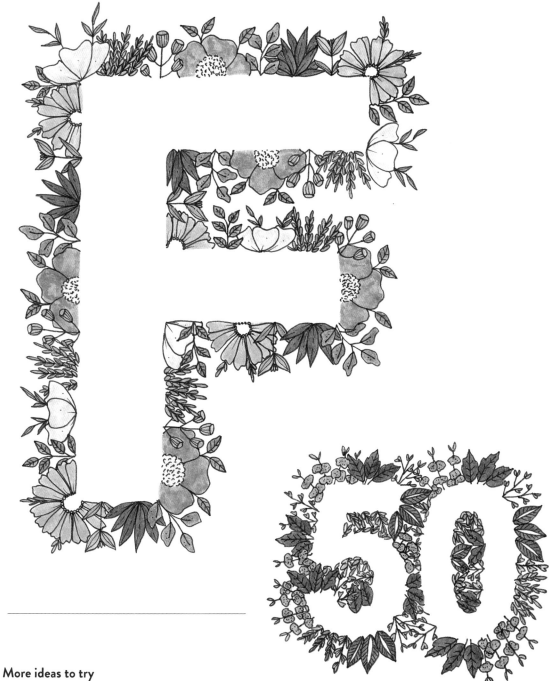

More ideas to try

- Draw the outlines of the letter in pen if you wish or draw the flowers and leaves on the inside of the letter rather than around the outside of it.

- Use the same technique for numbers – particularly good for birthday cards.

- Experiment with smaller, detailed flowers and leaves compared to bigger blooms and leaf sprigs.

Vessels

Doodling flowers in vases, jars or plant pots makes lovely designs for cards, stationery or stickers. Use your imagination to think up interesting vessels to fill; you could add flowers to watering cans, baskets, boxes, buckets, cups, sinks, bottles … anything you like! Here you will draw your own collection of vessels on a shelf, but you could also break this project down and draw single vessels, or a smaller set-up, if you prefer.

Time to complete
45 minutes

Flowers used
Cosmos (see page 34)
Daisy (see page 62)
Hydrangea (see page 40)
Lavender (see page 32)
Peony (see page 54)
Rose (see page 60)
Tulip (see page 38)

1

2

3

1 In the centre of your page sketch out a simple frame with a set of three shelves in pencil.

2 Add a variety of vessels to the shelves, changing up their shapes, using different heights and widths, and varying the spacing between them to make the design look natural. If you wish, you can also sketch a few vessels on the floor in front of the shelves.

3 Fill the vessels with flowers, drawing in different flower stems, buds and leaves.

4 Go over your sketch in pen and erase all of your pencil marks.

5 Decorate the vessels before adding the finishing touches to your petals, leaves and flower centres.

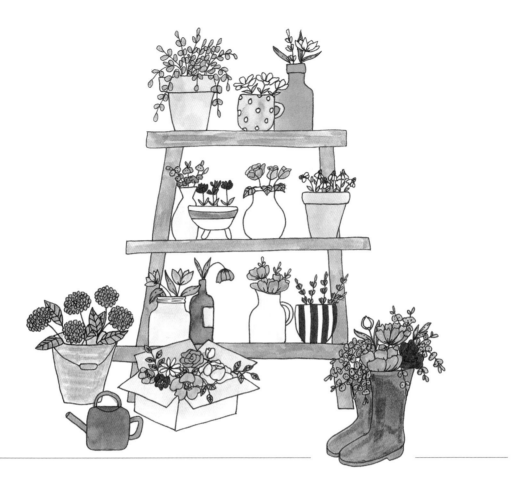

More ideas to try

- Get creative with your vessels. Why not try adding flowers to an ice cream cone, a shoe, a pumpkin, a teapot or a bicycle basket?

- Build up your picture by adding surrounding details such as a greenhouse, a window, a potting table or a florist shopfront.

- Try drawing simple vessels in a grid, as on page 72.

TIP

Consider whether you want your vessels to look like they are made of glass by drawing in stems and maybe a water line, or leaving these out to make the vessel appear solid.

Spiral

For the final project I've chosen an intricate spiral design which looks impressive but is very soothing to draw. If you look, you will find lots of spirals in nature – in shells, flower petals, pinecones, whirlpools and animal horns, to name a few examples. Spirals are widely recognized as a symbol of healing and movement, so I hope this exercise helps you reflect on your journey with drawing and creativity, and how this may have evolved as you've worked through this book.

Time to complete
120 minutes

Leaves used
Leaf shape D (see page 17)

1

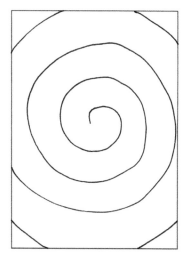

2

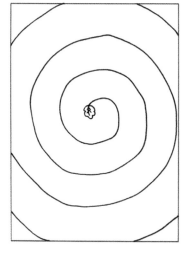

3

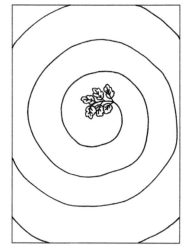

1 Using a pencil and starting in the centre of the page, draw a large, loose spiral until you reach the edges.

2 Draw a small leaf in the centre of the spiral (you can choose your favourite leaf shape from Chapter Two).

3 Add leaves and branches to the spiral on either side of the original leaf until you have four or five leaves on each side.

4 You can now start to make the branches a tiny bit longer and add multiple leaves to each branch. Try to vary the length, direction and number of branches as you work around the spiral, and keep adding leaves until you fill up the spiral.

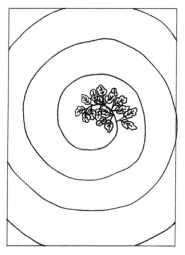

5 When you reach the edges of the page, continue to add leaves wherever the spiral is still showing in order to give the impression that the spiral continues and off the page.

6 Go over the pencil marks in pen and erase the pencil marks before finishing by adding some simple details such as colour or shading to the leaves.

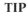

TIP

When you draw the guiding spiral, make sure to leave enough room in between each round for the leaf branches; if you draw it too tight, you won't have enough space. I also like to add a few leaves that sit across the original spiral line as I go, as this makes the finished design look more natural and breaks up any uneven or wobbly bits on the spiral line.

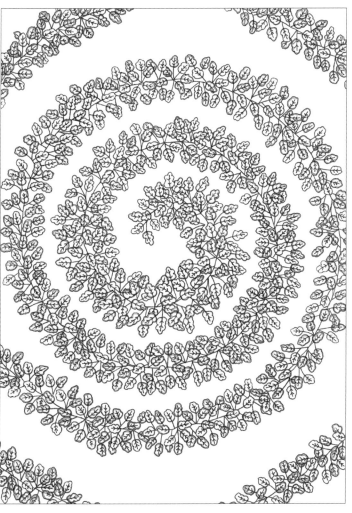

More ideas to try

- Trying adding different combinations of leaves and flowers to your spiral.

- You could use this technique with concentric circles or ellipses rather than a continuous spiral.

- If you feel like a challenge, try creating a more three-dimensional spiral that stretches vertically down the page in a cone or a helix.

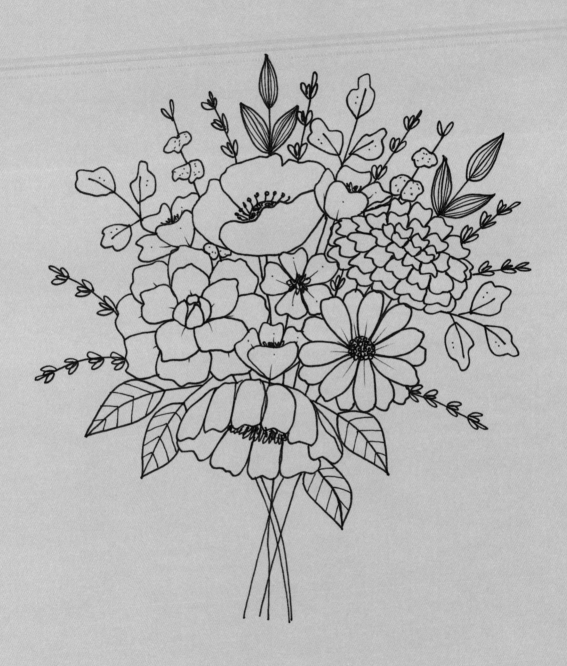

Chapter Five

Taking Your
Drawings Further

Developing your own style

Hopefully you'll have found that this book isn't about just copying the flowers and projects within it. My aim has been to help you learn how to go beyond the tutorials and create your own individual floral designs.

In order to really make them yours, you will need to develop your own unique drawing style. I believe the key to this is identifying what you really enjoy drawing, where you naturally excel or the aspects you find easiest. There is such a wide range of drawing styles but here are a few examples using a simple daisy flower to demonstrate. Ask yourself where you feel most drawn to and most comfortable along this scale from complex and life-like to simple and abstract:

1 Realistic, detailed shading. Lifelike flowers which are anatomically correct.

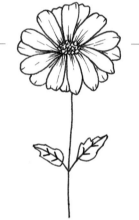

2 Lifelike flowers with shading and a sense of dimension.

3 Two-dimensional drawings with simple details to reference the original flower.

Finding your style

There are amazing artists out there at every point on the scale and in between. If you are struggling to figure out where you sit, my advice is to look online and try to find three to five artists you admire, whose work sits at different places along the scale, and have a go at drawing like they do. I wouldn't normally condone copying someone else's work but here it's purely for your own private experiment. It can be a really eye-opening exercise to work out what comes naturally to you and what you enjoy. When I first started drawing I thought my work would fall at the more realistic end of the scale, which was the style I was most drawn to. However, I quickly realized that I didn't have the patience or finesse to pull it off! I found I enjoyed the simpler, doodle style much more as I could create satisfying and effective line drawings within the half an hour I had available.

Once you have an idea what kind of style comes most naturally to you, I'd recommend you stop looking to other artists' work for inspiration so it doesn't stifle your own emerging creativity or lead to you inadvertently copying their work. Instead try to draw and practise as often as you can, daily if possible. Challenge yourself to draw flowers multiple ways and let your own style develop and evolve. Putting the time in and showing up to practise will pay off but it does require patience and a trust in the process.

4 Outline drawings simplifying the shape of the flower.

5 Simple drawings with experimental or abstract marks and details, such as a continuous-line drawing, made without lifting the pen from the paper.

My style falls somewhere in the middle of this scale. I like to keep my floral doodling simple, pretty and modern without too much shading but with a few details to add dimension and extra interest.

Finding inspiration

My top ten tips

1 Don't overcomplicate it! You don't need to reinvent the wheel. Keep your drawing fun and relaxed, and go back and do some of your favourite projects from this book whenever you feel like it.

2 Build a reference library of leaves and flowers you like to draw, so that whenever you're stuck you can look through them for flower or leaf ideas.

3 Take inspiration from the seasons – get outside and notice what is budding, blooming, seeding and fruiting at different times of year.

4 Look online for drawing challenges. There are lots of these, which typically run monthly and give daily drawing prompts.

5 Create a schedule to help you find time for drawing, or a devise a set programme to keep you disciplined. For example, have a set day for drawing a bouquet, a pattern, lettering and a wreath, then repeat this using different flowers each time.

I know how it feels when that dreaded blank page is staring back at you. It's easy to get caught up procrastinating rather than actually putting pen to paper, so here are my top tips for finding inspiration, overcoming mental hurdles and not letting your inner perfectionist win.

6 Don't be afraid to make mistakes. We've all drawn something that looks awful, but occasionally a risk really pays off. If you view drawing as a time to play and have fun, you might surprise yourself. Remember, it's about the process, not the end result!

7 If you're really stuck, get outside and search out a new leaf or petal shape you haven't drawn yet. If you can, visit a horticultural garden or greenhouse, and keep a bank of photos from your travels for inspiration.

8 Keep a sketchbook. By keeping all your drawings together, not only can you see your progress, but it can also be fun to revisit old work and recycle ideas with different flowers.

9 Draw on other mediums other than paper, such as pebbles, shells, leaves, pottery, wooden boxes or walls. A packet of Posca pens will more or less draw on anything so they're a good tool for your art kit.

10 Finally, it's a cliché but creativity is a muscle and the more you exercise it, the stronger it gets! Try to doodle every day if you can, even for a couple of minutes. You'll be surprised by how much you improve – and how many more ideas you have.

For a very practical helping hand, don't forget to download the free printable templates referred to throughout book by visiting *www.magicofflorals.com/booktemplates.*

What to do with your doodles

Doodling has always primarily been about relaxation for me. It's something I do for myself, for a little creative escape, so most of the time I stick to drawing in my sketchbook on the sofa with a cup of tea. However, there are lots of lovely, practical things you can use your floral drawings for, so here are a few ideas.

1
Decorate your home: Frame your drawings and use them as wall art to add a touch of nature, colour and personality to your walls.

2
Greeting cards: Turn them into greeting cards for special occasions like birthdays, weddings or holidays.

3
Notebook covers: Customize the cover of a notebook or journal with your flower drawings to make it your own.

4
Gift wrap: Repeat a simple design to create homemade wrapping paper and gift tags.

5
Stationery: Incorporate your flower drawings into personalized stationery like letterheads, envelopes or notepads.

6
Digital art: Scan or photograph your drawings to use as graphics for websites, blogs or social media posts.

7
Clothing & fabric: Transfer your flower doodles onto fabric to create custom clothing, scarves, tea towels or decorative cushion covers.

8
Jewellery: Miniature versions of your flower drawings could be turned into pendants, charms or earrings for unique and personalized jewellery.

9
Tattoos: Your flower drawings could inspire or be incorporated into original tattoo designs.

10
Product design: Your drawings could decorate mugs, tote bags or phone cases through print-on-demand services, which are widely available online. You could even consider starting a business!

11
Photo albums and scrapbooks: Add your drawings to the pages of a photo album or scrapbooking projects to enhance your memories with a personal touch.

12
Calendars & planners: Create your own custom calendar or planner pages featuring your flower drawings.

13
Colouring: The line doodle can be just the first step – floral designs make brilliant colouring projects too. Why not scan your drawings and make your own colouring book for others to enjoy?

14
Postcards: Transform your flower drawings into postcards to send to friends and family, or create a set to gift or sell.

15
Ceramics & pottery: Transfer your flower designs onto pottery items like mugs, plates, or vases at a pottery painting café or workshop.

16
Labels: Create labels for your potted plants, herbs and spices, sauces, jams and teas with artistic, hand-drawn labels featuring the corresponding botanical illustrations.

17
Business cards: Use your flower drawings in the design of your business cards (or scan to add to your email signature) to make a memorable and unique impression.

18
Weddings & parties: If you're hosting a wedding or a themed party, incorporate your flower drawings into decorations, place cards or invitations.

19
Stickers: Turn your flower drawings into stickers that can be used to decorate laptops, water bottles, notebooks, and so on.

20
Journalling: Decorate your journal or planner pages inside with floral doodles. They work well for habit or mood trackers, to divide up the months or to embellish titles and headers.

21
Seasonal decorations: Add floral doodles to candles, glass jars or even pumpkins at Halloween!

22
Embroidery patterns: Convert your flower drawings into patterns for embroidering onto clothing, soft furnishings or wall hangings.

23
Furniture: Beautify tired-looking furniture such as chairs, tables, or cabinets with a lick of paint and some hand-painted flower designs.

24
Bookmarks: Create designs inspired by your favourite books – it's a wonderful way to transform your doodles into a thoughtful gift.

25
Think big: Don't be afraid to expand your canvas and doodle on other surfaces other than paper. A set of Posca pens will enable you to draw your flowers on glass, wood, metal, plastic or wherever you wish to add some floral artistry!

Birth flowers
Each month has birth flowers assigned to it, just like a birth stone or a zodiac sign, and each flower has its own special meaning. Why not try using these flowers to design personalized cards, thank you gifts, wall art for a child's nursery or add floral doodles to your envelopes? You could draw a simple flower to celebrate the arrival of a new baby or even combine the birth flowers of all the members of a family into a family bouquet. I've included a quick guide to each month overleaf.

Birth flowers

JANUARY

Carnation: love, fascination and distinction

Snowdrop: rebirth and hope

FEBRUARY

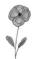
Violet: faithfulness and humility

Primrose: youth, young love and everlasting existence

MARCH

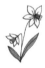
Daffodil: new beginnings, happiness and joy

Jonquil: desire and forgiveness

APRIL

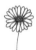
Daisy: cheerfulness, innocence, purity and beauty

Sweet pea: pleasure and goodbyes

MAY

Lily of the valley: sweetness, humility and a return to happiness

Hawthorn: hope and supreme happiness

JUNE

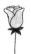
Rose: love, passion and friendship

Honeysuckle: everlasting bonds of love

JULY

Larkspur: dignity, positivity and love.

Water lily: innocence, purity and fertility

OCTOBER

Marigold: warmth, love, affection, optimism and prosperity

Cosmos: harmony and serenity

AUGUST

Gladiolus: strength and moral integrity

Poppy: relaxation, recovery and remembrance

NOVEMBER

Chrysanthemum: cheerfulness, loyalty and love

Peony: happiness, prosperity and good-fortune

SEPTEMBER

Aster: love, faith, wisdom and positivity

Morning glory: affection for someone near and dear

DECEMBER

Holly: peace and goodwill

Narcissus: faithfulness and respect

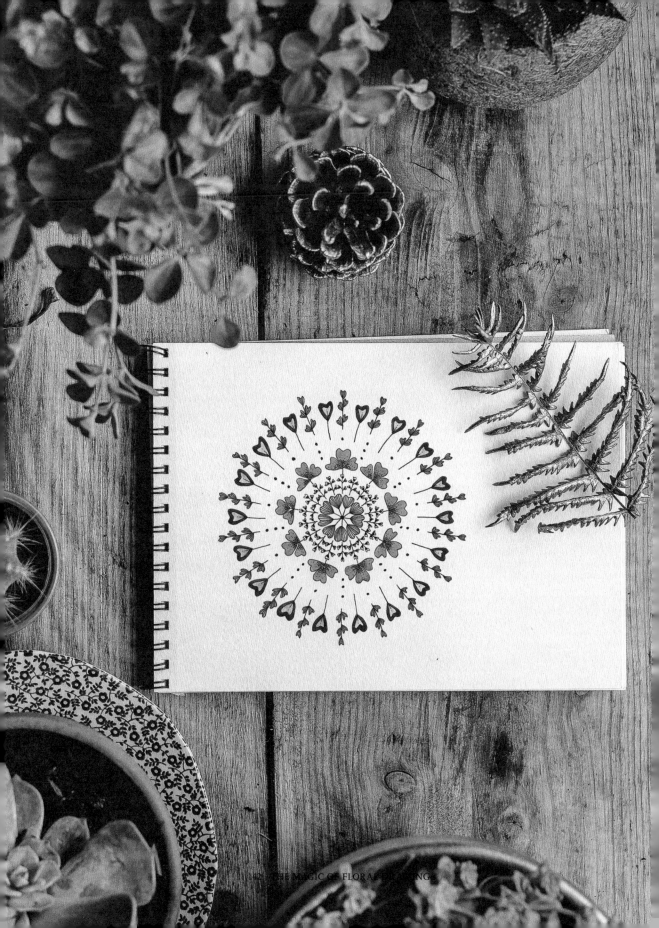

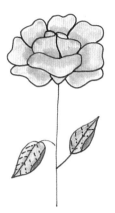

Elevating your drawings

Just before I ask you to draw another simple flower (as we did right at the beginning of the book on page 8), here is a quick summary of the key things we've covered to improve your floral doodles:

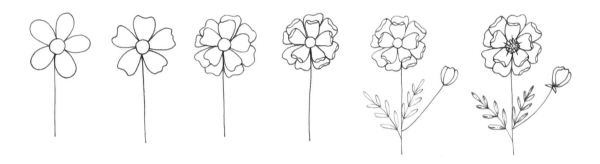

- Wiggle your pen a little as you draw the petals or leaves so that they aren't perfectly smooth. Tears, dips or slightly misshapen ends will instantly make your drawing look more natural and less cartoon-like.

- By including overlapping petals or layers rather than making them perfectly spaced, you will add more realism and visual interest to your flowers.

- Adding folds to the petals gives the flower more character and dimension.

- Include leaves, and perhaps add some extra buds or berries to the stems.

- Add details to the flower's centre and some shading to the leaves or petals to make them look more textured – even if it's just a few simple lines or dots.

- Draw your flower at an angle to give it more perspective and depth.

I would love it if you could now draw a flower next to the one you drew right back at the beginning of the book and share this with me on Instagram by tagging me (**@MagicOfFlorals**), and using the hashtag **#magicofflorals**. I can't wait to see your progress!

I hope you've enjoyed our floral doodling adventure together, and that this book has given you plenty of ideas to explore your creative side and use drawing as a mindful, self-care tool. Keep practising, experimenting and having fun with your floral doodles.

Acknowledgements

I am so grateful to everyone who has contributed and supported me in the creation of this book. Writing it with a newborn baby wasn't easy, but it was an incredible experience that will forever hold precious memories.

Firstly a heartfelt thank you to my lovely editor Ellie and all the team at Ilex Press, who offered me reassurance, expertise and insightful feedback throughout the process. I feel extremely fortunate to have had the opportunity to work with such a lovely and talented team, so thank you for believing in me and making my dream of publishing this book a reality!

Thank you to my parents, who spent countless hours babysitting, doing school runs, ironing, gardening, swimming-lesson duties, tip-runs, jet-washing, dog-walking, and so much more, so that I could work on these pages. I am eternally grateful for everything you do to support me. Your unwavering love, dedication and encouragement are amazing.

I also want to extend a special thank you to my mother-in-law for her weekly Grandma duties. Those extra few hours each week were a massive help in keeping on top of everything during such a busy time, and I really appreciate your presence.

Thank you to my husband for your patience, understanding and endless support – you kept me going whenever the self-doubt kicked in or the sleep deprivation got too much! I couldn't have asked for a better partner in life and in book-writing. And yes, you do get brownie points for all the proofreading and cups of tea!

To our beloved children, Casper and Fleur: this book is dedicated to you. You are my inspiration, my motivation and my greatest creation. I hope this book always reminds you to do something you love, just for you, and that you can make your dreams happen if you work hard enough.

Last, but certainly not least, thank you to you – my readers and all my wonderful followers on Instagram. I appreciate your kind words and encouragement so much. Thank you for being part of this journey with me.

To everyone mentioned above and all those who have supported and believed in me, thank you from the bottom of my heart. This book is as much yours as it is mine.

With love and gratitude,
Chloe x

PS: A few random facts…
While making this book I wore out 6 fine-liner pens, used approximately 320 sheets of watercolour paper and made around 60 bowls of homemade vegetable soup (lunch for my parents and me on their days here helping)!

References
https://www.woodlandtrust.org.uk
https://www.rhs.org.uk

Picture credits
https://fionacarolinebranding.com
Unsplash: Annie Spratt 142; Dee Copper and Wild 10;
Kseniya Lapteva 4, 139, 140, 141; Nahil Naseer 14; Pure Julia 6